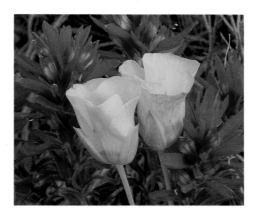

GOLDEN MARIPOSA
Calochortus aureus
COMMON PAINTBRUSH
Castilleja chromosa

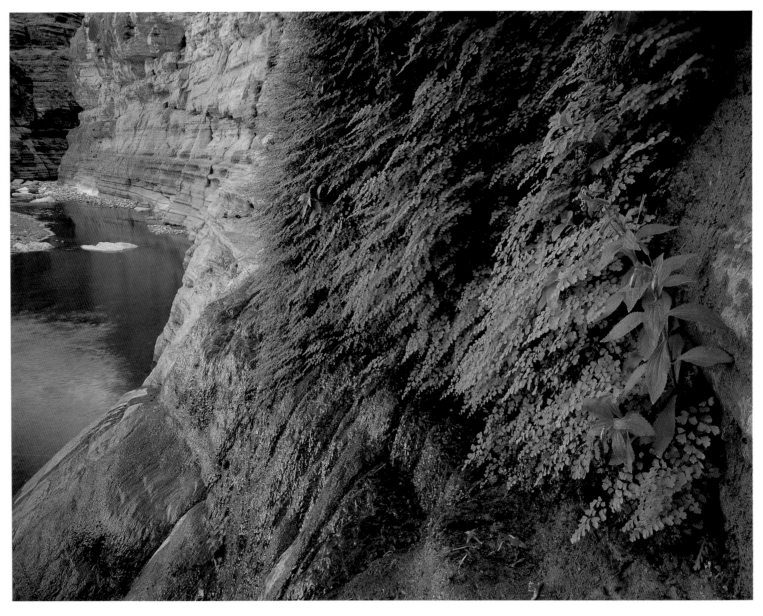

CARDINAL MONKEY–FLOWER *Mimulus cardinalis*
~ WITH MAIDENHAIR FERN

Kanab Creek, Grand Canyon
Grand Canyon National Park, Arizona
April 15, 1990

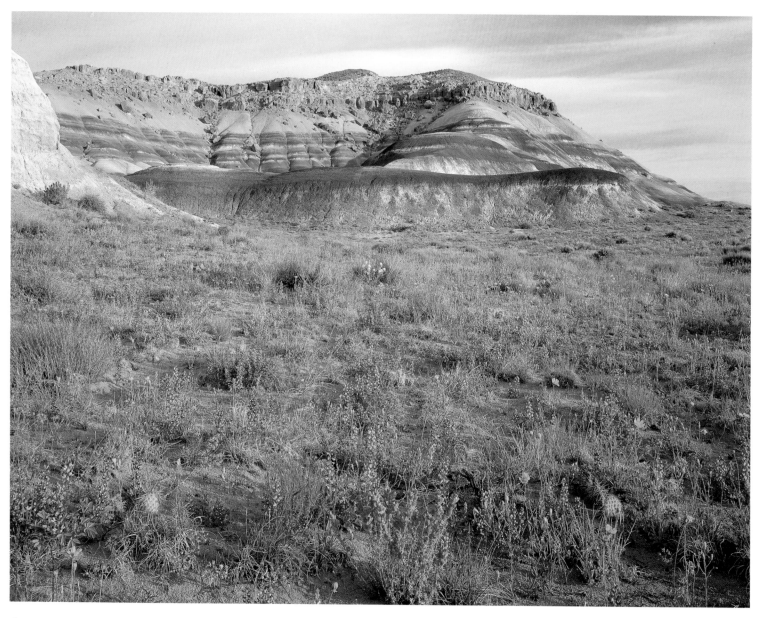

GOOSE-BERRY-LEAF GLOBEMALLOW *Sphaeralcea grossulariifolia* var. *grossulariifolia*
DWARF LUPINE *Lupinus pusillus*
YELLOW CRYPTANTH *Cryptantha flava*
SCAPOSE GREENTHREAD *Thelesperma subnudum* var. *subnudum*

River Ford Road
Bureau of Land Management
Henry Mountains Resource Area, Utah
May 21, 1995

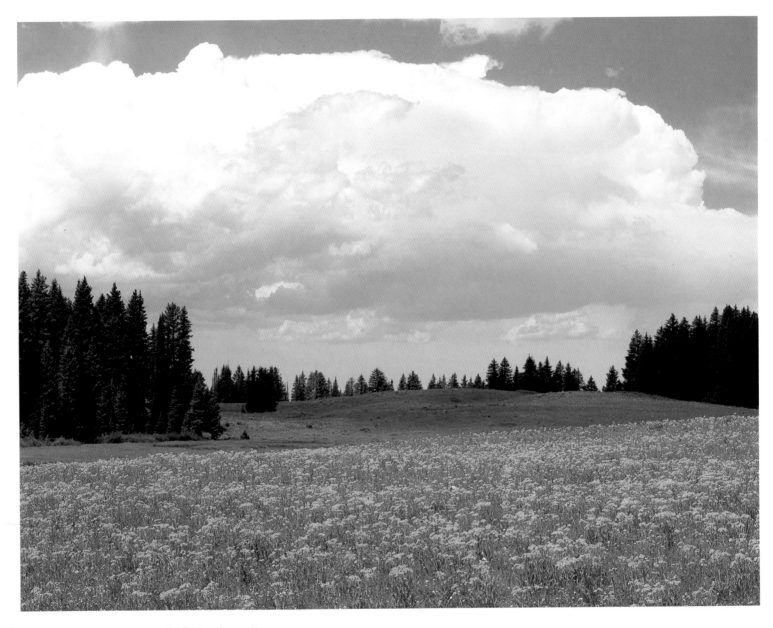

ORANGE SNEEZEWEED *Helenium hoopesii*

Flowing Park Road, Grand Mesa
Grand Mesa National Forest, Colorado
July 12, 1994

Wildflowers

OF THE PLATEAU & CANYON COUNTRY

KENNEDY'S MARIPOSA
Calochortus kennedyi

Peach Springs Canyon
Hualapai Indian Reservation, Arizona
May 3, 1995

Photography by
LARRY ULRICH

Interpretive Text by Susan Lamb

COMPANION PRESS
SANTA BARBARA, CALIFORNIA

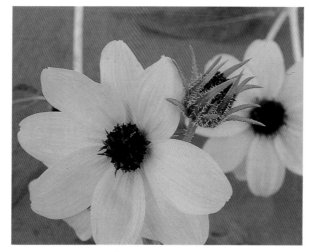

SAND SUNFLOWER
Helianthus anomalus

Twenty Mile Wash, Hole in the Rock Road
Bureau of Land Management
Escalante Resource Area, Utah
September 28, 1994

Companion Press
464 Terrace Road
Santa Barbara, CA 93109
Jane Freeburg, Publisher/Editor
Designed by Lucy Brown

Printed and bound in Korea
through Bolton Associates
San Rafael, California

Library of Congress Catalog Number: 95-083334

ISBN 0-944197-41-8 (paperback)
ISBN 0-944197-42-6 (clothbound)

96 97 98 99 ✦ 4 3 2 1

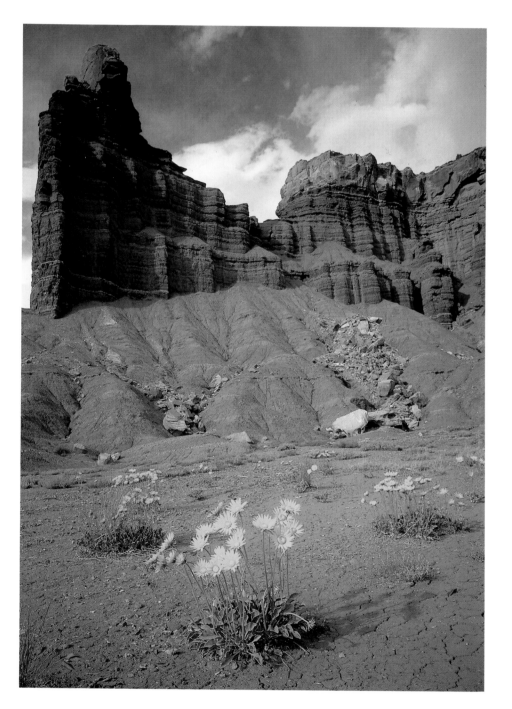

Contents

NAKEDSTEM SUNRAY
Enceliopsis nudicaulis

Chimney Rock, Highway 24
Capitol Reef National Park, Utah
May 3, 1992

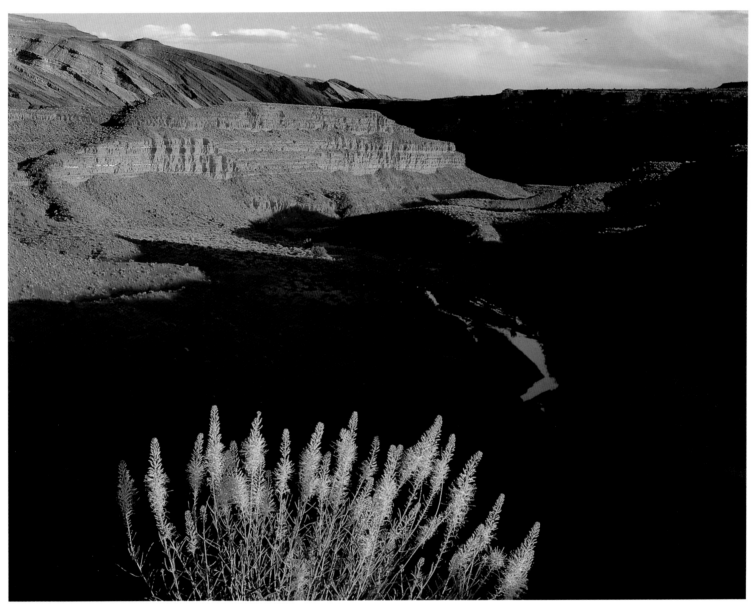

PRINCE'S PLUME *Stanleya pinnata*

Lime Creek and Raplee Ridge
Bureau of Land Management San Juan Resource Area, Utah
June 1, 1995

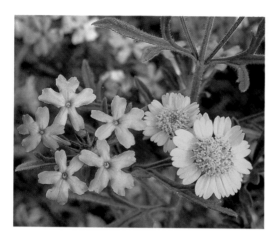

PREFACE

*F*alling in love with the Colorado Plateau was easy. I was recovering from a skiing accident in 1974 that had my leg wrapped in plaster for the spring and I could only dream of hiking. Larry brought a book home to cheer me up—*Slickrock: Endangered Canyons of the Southwest,* with photographs by Philip Hyde and words by Edward Abbey. The stunning photographs of red-rock spires, piñon pines and impossible-to-imagine canyons produced the desired effect. It was love at first sight; we had to go see it for ourselves.

So we invited my brother and his 4x4 and left Lake Tahoe on the first day of spring vacation. Lance's Jeep CJ5 was packed with camping gear, Larry rode shotgun, and I sat in the back seat with my leg propped up on the ice chest. We had the AAA map of Indian Country and *Slickrock* by our sides, our bibles showing us the way. It was a whirlwind adventure that took us first to Escalante, then to Canyonlands National Park, around "the Grand Circle" and up into the San Juan Mountains of Colorado where we had our first peek at the Rockies. Now-familiar places sailed by like pages in a travel magazine, too gorgeous to believe.

After countless trips into the canyon country we are no longer strangers discovering for the first time, but old friends back to explore again. Each curve in a road or trail reveals new pleasures—towering rock hoodoos rising from the canyon floor, petroglyphs, old homesteads, wildflowers. Sandstone is everywhere: it binds and defines the Plateau, providing an ego and personality.

PROSTRATE VERBENA
Verbena bracteata
YELLOW RAGWEED
Bahia dissecta

Junction Cave Picnic Area
El Malpais National
Monument, New Mexico
October 6, 1994

Horizontal layers of sandstone have been lifted, tilted, tortured and twisted. There is a reason this vast region of canyons and plateaus contains over a dozen National Parks and Monuments—it is bursting with the kind of beauty that draws travelers from all over the world.

Although the spectacular redrock canyons are the obvious attraction for hikers, bikers and jeepers, something more subtle seizes our senses and brings us back again to look deeper. The noisy sweep of a raven's wings as she scours the canyon walls for dinner, the quiet-shattering trill of the canyon wren, somewhere unseen in the rocks. The evidence of civilizations, past and present, is everywhere. Playful rock, twisted into forms we identify with predictable names, march across the landscape like tired carousers from Mardi Gras. There are enough surprises for a lifetime.

Perhaps the greatest surprise is the profusion of wildflowers. Amid all the river and rock, it is easy to overlook a daisy. The steep canyon walls most often associated with the Plateau are generally lacking in vegetation. But where the rapid erosion that typifies the badlands of the Colorado Plateau has slowed, geology gives vegetation a chance. Flowering plants grow within the broad, flat divides formed between uplifted mountains and on the gentle slopes along the many rivers. On mesa tops and in valleys full of rich, volcanic soil, wildflowers flourish. Abundant summer monsoon rains bring the mesas, at 10,000 feet, enough precipitation to create a tapestry of color. Snow melt feeds the ephemerals (plants that bloom only when there is enough moisture), bringing deserts and valleys life.

There are places that spawn native plants year after year with dependable regularity. At Grand Mesa, outside Grand Junction, Colorado, wildflowers bloom when the snow clears until it falls again. Marsh-marigolds push their dark green leaves out through the snow and shove their white disk faces out to welcome spring. Fields of sunflowers and silvery lupine slowly fade and finally sink to the ground under the weight of the first snows. Grand Canyon itself is a wonderland of species. Larry and I have floated the Colorado River three times through 280 miles of habitat that

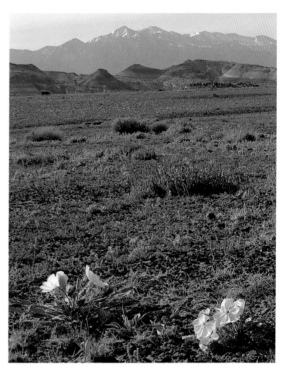

TUFTED EVENING-PRIMROSE
Oenothera caespitosa var. *marginata*
CRENULATE PHACELIA
Phacelia crenulata var. *corrugata*

River Ford Road
Bentonite Hills
and the Henry Mountains
Bureau of Land Management·
Henry Mountains
Resource Area, Utah
May 21, 1995

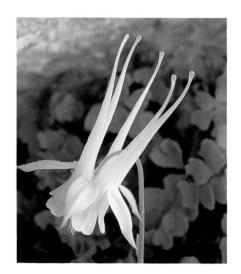

ALCOVE COLUMBINE
Aquilegia micrantha
~ WITH MAIDENHAIR FERN

Alcoves near trail to Delicate Arch
Arches National Park, Utah
May 22, 1994

changes daily and harbors plants from desert-dry claretcup cactus to water-loving monkey-flower. The first time we visited the Uncompahgre Plateau in Colorado we saw a surprising landscape atop a 10,000-foot mesa. Tiny penstemon, elegant lion's-beards, and diminutive cactus made us slow down as we walked across the rich environment. In the White Mountains of Arizona streams stocked with trout are lined with New Mexico checker, sneeze-weed, and columbine. Cedar Breaks National Monument in Utah is possibly one of the biggest surprises of all. The main attraction is the Bryce Canyon-like badlands of orange and white. After the view over the railing has faded, an endless tapestry of Colorado blue columbine, paintbrush, and sunflowers invite the visitor for a stroll.

All this beauty is not without its price. The region is in danger of being loved to death. Overzealous freewheeling ORV-ers and hordes of hikers and bikers with no manners threaten to trample it to pieces. Water-hungry towns, growing into cities at unsustainable rates, are sucking the water table dry, slowly killing the deserts. Cows (Ed Abbey called them "slow elk") are eating it to death. As a result, native vegetation has been severely impacted outside state and federally-protected parks. Until Golden Eagle Passes become available to cows for entrance into National Parks, these havens are our best chances to find and enjoy native wildflowers.

Photographing and identifying the species for this edition was a pleasure, but also a dilemma. Publishing a book on an area we love has its drawbacks. Didn't Phil Hyde and Ed Abbey send *us* off to Slickrock Country? Now, twenty years later, we find ourselves showcasing the beauty of the Colorado Plateau. But, for probably the same reasons the Sierra Club published *Slickrock*, we present *Wildflowers of the Plateau & Canyon Country*. This volume, like our previously-published *Wildflowers of California*, is not a field guide but a visual interpretation of the diversity, abundance, and beauty of the Colorado Plateau's native flora. These photographs are our contribution to public awareness of the treasures of the Plateau. Wildflowers can be overlooked easily and we want people to notice and take care of them. They are just too gorgeous to ignore.

—DONNA B. ULRICH

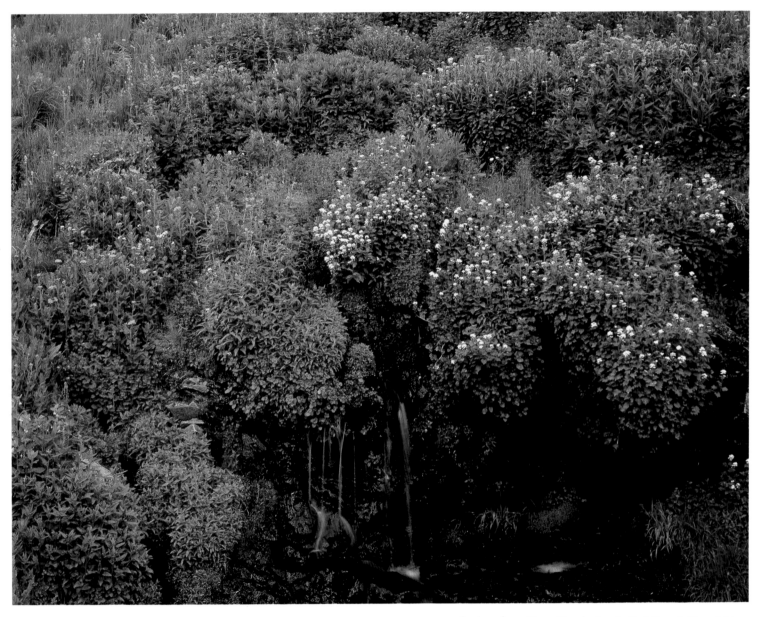

ARROWLEAF GROUNDSEL *Senecio triangularis*
HEARTLEAF BITTERCRESS *Cardamine cordifolia*
MOUNTAIN BLUEBELL *Mertensia ciliata*
MONKSHOOD *Aconitum columbianum*

Spring along Deep Creek, Lands End Road, Grand Mesa
Grand Mesa National Forest, Colorado
July 24, 1995

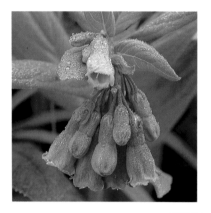

People from a planet without flowers would think we must be mad with joy…to have such things.

–Iris Murdoch

There are many keys that unlock the mysteries of a place; many ways to understand its nature. In the formidable, rockbound realm of the plateau and canyon country, wildflowers are living guides—bright-faced geographers who tell us that the elevation here is high, the climate extreme, and the water scarce.

Two-legged geographers have long described the Colorado Plateau as a distinct physiographic province, a 130,000-square-mile tableland of ancient rock whose present surface averages more than a mile above sea level. The plateau is bordered on the north and east by the Rockies, on the west by the Wasatch Line, and on the south by the Mogollon Rim. It takes its name from the Colorado River, which together with innumerable tributaries carries rainfall and snowmelt from parts of Utah, Arizona, New Mexico, and Colorado to the Gulf of California, carving great canyons and intimate niches into the layers of colorful rock along its way.

However, such geographical assertions only set the grand stage of the Colorado Plateau. For many people, the plateau remains an intimidating landscape, difficult to relate to at first. Apparently, the appreciation of such scenery is a cultivated taste. Journals of the first Europeans to encounter the canyon country—from the Spanish conquistadors in 1540, to French and Anglo trappers, to early topographic expeditions—variously described it as appalling, frustrating, or at best of little importance. Only after it was interpreted by scientists, writers, and painters did Americans actually begin to like what soldier-geographer Clarence Dutton called "a great innovation in modern ideas of scenery, and in our conception of the grandeur, beauty, and power of nature."

It seems that the appreciation of this sort of scenery is also an adult taste. A survey done at Grand Canyon found children to be far less intrigued with the spectacular vistas there than with the mule deer, the ravens, and yes, the colorful flowers.

He who is born with a silver spoon in his mouth is generally considered a fortunate person, but his good fortune is small compared to that of the happy mortal who is born with a passion for flowers in his soul.

—CELIA THAXTER

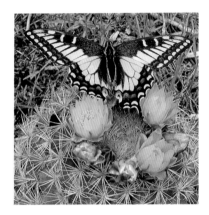

So it is that when many of us visit the Colorado Plateau, we look curiously about for signs of life. And to our delight, we discover wildflowers. Most of us relate quite effortlessly to these cheery faces of nature. Certainly the only thing I remember learning in kindergarten was how to be a flower. In a school play, four other buttercups and I crouched on the stage of the multi-purpose room, curled over our knees with just our leafy green arms and the backs of our sepal-hats showing. Then the sun (a lofty third-grader festooned with streamers of gold foil) paraded past us. We stirred, opened our arms wide, stood, and turned up our heads, our little faces beaming from the centers of floppy yellow petals to what seemed like thunderous applause from our parents.

I am reminded of that happy moment each spring in the plateau and canyon country, when after months of snow and early darkness I greet flowers that seem as sweet and fragile as those children. But like children, Colorado Plateau wildflowers are surprisingly tough, resilient, and diverse. They prove that although this is a land of extremes, sun-blasted yet subject to freezing almost any night of the year, still there are many strategies not only for survival, but for blooming.

SIMPSON'S FOOTCACTUS
Pediocactus simpsonii
~WITH ANISE SWALLOWTAIL

Jones Hole Trail
Jones Hole
Dinosaur National
Monument, Utah
May 27, 1995

At first glance, the great expanse of the Colorado Plateau appears fairly meager and monotonous in its range of plantlife. Shrubby stretches of sage- and rabbitbrush, saltbush, and snakeweed roll to the horizon in many places. Forests are composed of just a few different kinds of conspicuous trees: up to around 6,500 feet, they are "pygmy" forests of short, widely-spaced juniper and pinyon pine; from there to about 8,000 feet, ponderosa pine and Gambel oak predominate. Above and in cooler places loom stands of Douglas fir and aspen, and from there to treeline, blue and Engelmann spruce mingle with subalpine fir. However, a closer look reveals that these shrubs and trees share the landscape with thousands of other flowering plants, many of them endemics found only in the plateau and canyon country.

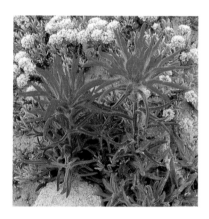

I believe a leaf of grass is no less than the journeywork of the stars.

—WALT WHITMAN

SLICKROCK PAINTBRUSH
Castilleja scabrida var. *scabrida*
PRETTY BUCKWHEAT
Eriogonum bicolor

Notom Cutoff Road
Blue Flats
Bureau of Land
Management
Henry Mountains
Resource Area, Utah
May 7, 1995

*W*hy are there so many different flowers here? They may be understood as thousands of ways to cope with a daunting climate and topography. The Colorado Plateau lies in the arid interior of the continent, where rainfall averages less than twenty inches a year. Sunlight scorches this high country in the daytime but its warmth radiates away quickly through the dry air at night. The temperature often yo-yos thirty or forty degrees from noon to midnight and back again. A very short growing season means that flowers must bloom, be pollinated, and set seed quickly. Furthermore, wildflowers isolated in deeply-etched canyons or remote nooks do not mix easily

with plant communities that lie across the exposed, sunblasted rocks, and so they gradually evolve into new and unique forms.

Most plateau flowers—bladderpods, for instance—are small in order to conserve water and to limit their exposure to the elements. Their skimpy foliage is often waxy, or like that of the cliffrose it may be sticky with fragrant, protective resins. Tiny hairs buffer the bracts and leaves of flowers such as fleabane and paintbrush. Other flowers may not appear for years, until adequate snowmelt or rain signals their seeds or bulbs to produce.

Some cactus and other plateau plants do have huge blossoms. Cactus sustain theirs by bonding water in a sort of gel within their thick-skinned stems. Datura and evening primrose have large tubers, and only unfurl their generous blooms in the cool hours after sunset just as moths appear to pollinate them. Columbines and monkey-flowers grow in shady places or near seeps and springs where their roots stay moist. Big yellow sunflowers delay blooming—or emerge much dwarfed—until the summer rains begin.

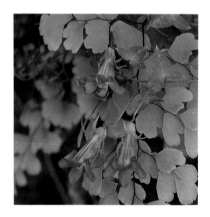

The Earth laughs in flowers.

—RALPH WALDO EMERSON

*T*he Colorado Plateau receives its scant moisture during two seasons: in winter and during the summer "monsoons." As a result, there are two blooming seasons here.

Prevailing winds reverse direction twice a year in a messy and erratic fashion. In fall and winter, soggy weather fronts blow across the Southwest from the Pacific Ocean. Although the coastal ranges and Sierra Nevada wring much

TWINING SNAPDRAGON
Maurandya antirrhiniflora
~ WITH MAIDENHAIR FERN

Fern Glen Canyon
Grand Canyon
Grand Canyon National
Park, Arizona
April 19, 1990

16

of the snow and rain out of these storms, enough gets through to bring a blush
of spring flowers to the plateau from about March through May. Blooming
begins once days are long and warm enough for snows to melt, soils to warm,
and pollinators to survive. Newly arrived from southern lowlands, hummingbirds
whir above the red tubes of paintbrush and penstemon. Checkerspot butterflies
flit about in search of delicate asters. Skyrockets burst up from battered green
rosettes of overwintering leaves, and cardinal monkey-flowers peep from rock
crevices around seeps. Little pink fleabanes blos-
som early but close up at night, often sheltering
small flies as well as their own centers from cold
and wind.

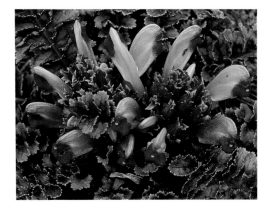

 Snowmelt and spring rain are mostly over
with by the end of May. June tends to be a dry
and difficult month for wildflowers, especially in
exposed places or at lower, hotter elevations on
the plateau. Yet along streams, in shady places,
and at lofty elevations, spring merges with sum-
mer as flowers bloom one after the other, keeping
pollinators in the neighborhood. Yarrow, star-
lilies, and lupine open in the ponderosa forest and
Gambel oak woodlands as adelpha butterflies dodge among patches of dappled
sunlight. At even higher elevations, bluebells and bittercress, larkspur and colum-
bine bloom in profusion to a symphony of hummingbirds and buzzing bees.

 At last the rainy season, or "monsoon" (from the Arabic *mausim*, meaning
"season") comes when the winds shift to those originating in the Gulf of Mexico
and other points south. Mornings in July and August usually dawn clear and crisp
but clouds appear by afternoon, growing into cauliflower shapes that can tower
seven miles up into the sky. Crackling with thunder and lightning, they drift
slowly across the plateau and canyon country, their heavy tails of black rain
tickling the golden heads of dozens of members of the sunflower family into
bloom. Though intense, these rainstorms are very localized, causing bright
patches of verbena, beeplant, and thistle to spring up here and there across the
plateau. The summer air reeks with the perfume of cliffrose, and creamy blooms
star the branchtips of fendlerbush.

PINYON-JUNIPER
LOUSEWORT
Pedicularis centranthera

Whitman Bench
Bryce Canyon
National Park
Paunsaugunt Plateau
Utah
June 7, 1995

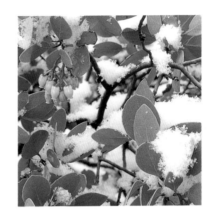

Climate is what you expect;
Weather is what you get.

–RICHARD A. KEEN

*T*he fickleness of the plateau climate is legendary,
however. From a flower's standpoint, the weather's most significant characteris-
tic is that it can vary so much from place to place, from day to day, and from
year to year. Meteorologist Kurt Meyers summarizes the climate of Flagstaff,
for example, in two words: "extremes" and "surprises." Snow fell heavily at
noon one recent June 17, while exactly five days later, Flagstaffians lolled at
sidewalk cafes enjoying lunch in a balmy 76 degrees. The monsoon rains can
begin just after the summer solstice, but they may not arrive until mid–August
(and in dire years they do not come at all). Thus, the wildflowers of the plateau
and canyon country act not only as geographers illustrating the position of the
plateau, but also as meteorologists reporting on the weather: "Yep, sure did
snow a lot this winter," nod thousands of usually-rare sego lilies in the Grand
Canyon. "Not much rain this summer, though" rustle a few sparse and short-
ened sunflowers at Sunset Crater.

Flowers are also historians, revealing the long-term changes that have
occurred in the regional climate. We may think of plants as rooted in stable
ecosystems for generation after generation, but they aren't. Because the earth's
climate is continually changing, plants must be able to evolve or move. All
flower species have migrational histories, just as people and other animals do.

Studies of preserved plants and pollen show that the distribution of all
species ebbs and flows across the plateau and up and down canyon walls with
the centuries, even traveling from one part of the region to another as the
climate warms or cools. Over the millennia, the different plants of the Colorado
Plateau have combined in communities, dispersed, migrated, and recombined to

GREENLEAF MANZANITA
Arctostaphylos patula

Rim Trail
near Inspiration Point
Bryce Canyon
National Park
Paunsaugunt Plateau, Utah
June 8, 1995

form new communities. Flowering plants will attempt to colonize wherever their runners and rhizomes reach or their seeds happen to land, but they will succeed only in places that suit them. One aspect of conservation is preserving enough habitat to allow this to occur, and one of the most critical elements of plateau habitats is water. Lowering a water table or interfering with how water flows down a slope or a canyon can have far-reaching consequences anywhere, but especially here.

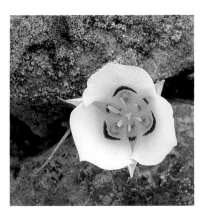

For thousands of miles my chief converse has been in the wilderness with the spontaneous productions of nature; and the study of these objects and their contemplation has been to me a source of constant delight.

—THOMAS NUTALL

SEGO LILY
Calochortus nuttallii

Needles District
Canyonlands National Park
Utah
May 20, 1994

*T*oday, people come from all over the world to visit the Colorado Plateau's nine national parks, thirteen national monuments, extensive national forests, and other designated public lands. Yet this region was actually the last part of what are now the lower forty-eight states to be explored by European-Americans.

In the nineteenth century, a few intrepid (and often eccentric) naturalists began to investigate the intermountain west in the company of military expeditions and sometimes entirely on their own. Our knowledge of the plateau's thousands of wildflowers began with the many field seasons they spent tramping its canyons and mesas and floating its rivers, learning from its native people, taking notes, sketching, and pressing plants. A number of flowers in this book bear names immortalizing these early adventurers,most of whom knew each other and made up a rather tight circle. *Calochortus nuttallii*, for instance, is the Latin name for the sego lily. According to Washington Irving, Canadian

voyageurs regarded Nuttall "as some whimsical kind of madman" who used his rifle to dig up plants and as a place to store seeds. *Mahonia fremontii* commemorates the dashing gloryseeker Captain John Charles Fremont. George Engelmann's name was bestowed on a wide range of plants from prickly pears to spruce trees, largely because Engelmann advised and underwrote other plant collectors in addition to making his own forays west.

The wild plant communities of the Colorado Plateau have changed considerably since the days of Nuttall, Fremont, and Engelmann. Plants introduced from other parts of the world have spread quickly here. Streams have been dammed or diverted, forests logged, meadows grazed, and big chunks of habitat developed into human communities where native plants are no longer welcome. However, the work of early naturalists provides a baseline by which we may gauge the rate and extent of this change and its effects on the other members of plateau ecosystems.

Flowers changed the face of the planet.
Without them, the world we know…
would never have existed.

—LOREN EISELEY

*T*here is a correlation between the diversity of plants and the richness of the animal community. Along with the various spring flowers on the Colorado Plateau, there comes a flush of the specialized insects that consume their nectar, pollen, and even petals. This causes a boom in the number of spiders, mantids, walking sticks, and dragonflies that prey on the plant-eaters. Lizards fatten on this population surge and reproduce, while birds—some local, some migratory—feast on the flower nectar or the insects, or even the lizards to sustain themselves and raise their nestlings. Mice eat flowers,

FENDLERBUSH
Fendlera rupicola

East Rim near park entrance
Mesa Verde National Park
Colorado
June 3, 1995

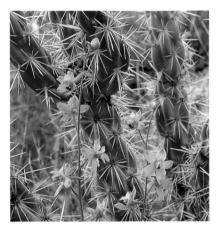

seeds, and bugs and in turn become dinner for hawks, owls, coyotes, and ringtails. Deer browse shrubs; rabbits, pronghorn, and elk nibble the grasses and flowers. This is only a small sampling of the relationships here, but they show how the health of the ecosystem begins with its plants and is reflected in the rest of the community.

Plant diversity is also important to the plants themselves. We often assume that plants are engaged in a continual, fierce competition for water and nutrients, but botanists know of many ways that they interact to benefit one another. Different flowers blossom in sequence, keeping bird, bat, and insect pollinators close at hand. The strong scent of natives such as sand verbena can attract pollinators from many miles away to benefit less fragrant flower neighbors. Some plants even change the color of their flowers as the season progresses: scarlet gilia are red

in early summer to appeal to rufous hummingbirds, but bloom in a paler shade to attract sphinx moths later in the season. Certain flowering plants benefit others by exuding various chemicals and nutrients from their roots, and scientists are only beginning to understand the threadlike fungus, or mycorrhizae, that transfer phosphorus, carbon, nitrogen, and who knows what

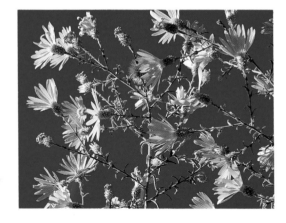

else between plants of different species. Flowering plants also provide shade, mulch, screening from drying winds, and climbing support for each other. Non-native flowers cannot always fulfill such roles. And natural communities are subject to chaos, or turbulence—meaning that even tiny changes in a natural system are magnified with unforeseeable results.

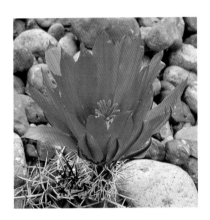

More than anything, I must have flowers, always, always.

—CLAUDE MONET

\mathcal{W}e are all familiar with a host of practical reasons to conserve the diversity of wild plants. To begin with, the natural world is often portrayed as a storehouse of potentially valuable chemicals. In addition, farmers and plant breeders know that it is sometimes necessary to tap the gene pool of wild plants to sustain the vigor of domesticated ones. Landscaping with native plants is a way to conserve resources, especially water. The Wall Street Journal reports that certain plants can even absorb dangerous contaminants from soil, including chromium from the site of a smelter in New Jersey and radioactive strontium and cesium from croplands around the Chernobyl nuclear reactor. Plants have potential as cosmetics, as fibers, and as fuel, and people have long known that substances found in many flowering plants can heal the sick.

Now, research cited in the New York Times indicates that the mere presence of flourishing plants, particularly in their natural setting, can help to cure us. A study by Dr. Robert Ulrich shows that people heal faster and feel less pain if they have a view of nature while they recuperate from surgery. Caring for plants is gaining a significant role in physical therapy, partly because of the combination of relaxation and effort it entails but also, according to a patient, because "It feels really good to be touching the soil and plants again." And even in cases where there is no hope, research shows that people with terminal conditions experience less anxiety when they can commune with nature.

Being close to a community of plants is beneficial to our peace of mind in other ways. The neurologist Dr. Oliver Sacks "had people who were so anxious

FENDLER HEDGEHOG
Echinocereus fendleri

Blue Mesa
Petrified Forest
National Park, Arizona
May 25, 1994

in the hospital that I would do my consultations in the greenhouse. They would often feel less pressured there and have less tics and involuntary movements." People with Alzheimer's disease have been measurably less agitated or violent when they could walk in gardens, and therapist Rebecca Reynolds uses flowering plants to help troubled children in locked psychiatric wards. As fellow counselor Joanne Keir explains: "Just being in contact with nature is very relaxing." Concludes Patrick Mooney, who teaches landscape architecture and studies nature's effect on us: "Until it becomes common knowledge that the experience in naturalistic environments is fundamental to psychological wellness—whether in the normal population or a special population—then we cannot make the case for really improving the human condition."

For the sake of a single poem, you must ...know the gesture which small flowers make when they open in the morning.

–Rainier Maria Rilke

SPIDER MILKWEED
Asclepias asperula var. *asperula*

Needles District
Canyonlands
National Park, Utah
May 20, 1994

𝓕lowers encountered in their wild context, especially one as daunting as the Colorado Plateau, are more than a comfort. They are an epiphany, a face of Nature, a "reality check." They have inspired artists and poets, scientists and mystics, but they can speak to anyone.

I myself first came to the Colorado Plateau one blustery April a dozen years ago, to work as a naturalist at Tusayan Pueblo, an ancient ruin on the rim of Grand Canyon. Built around A.D. 1185, Tusayan is a pile of rocks today, almost lost in a scraggly pine and juniper forest at about seven thousand feet in elevation. Bundled in a woolly hat, boots, and layers of winter bunting, I clomped anxiously around the site—a dismal prospect indeed under its crust of icy snow.

I struggled to imagine the villagers of eight centuries before cultivating corn and squash in the ridiculously short growing season, and peered with utter bafflement into exhibit cases displaying exquisite pottery, carved gaming pieces, and bone whistles. How could those people have made such lovely objects in this harsh place?

It was wildflowers that led me to appreciate life at Tusayan. When I found paintbrush and fleabane blooming among the old stone walls a week later, suddenly I understood that it is possible to flourish under difficult conditions, and that although the warmth may be fleeting and the rains may be scant, they are enough. After all, the wildflowers here are philosophers, too. Whenever and wherever they bloom, they are saying "this is a perfect moment: enough rain came when we needed it, the sun is shining, and we expect a beetle or a bee along here any time now."

Hopi people are the descendants of the Puebloans who lived at Tusayan and throughout the Colorado Plateau long ago. Puebloan people were—and still are—farming people, who watch the cycle of seasons and the growth of wild and cultivated plants with intense absorption. According to ethnobotanist Alfred Whiting, Hopi tradition holds that all living things lead an existence parallel to the one we see. Plants have a human form in another realm, where they talk about us. Traditional Hopis endeavor to be considerate of plants and to thank the flowers that they collect for food, dyes, and medicines. They invite wild plants into their gardens, dance with them in ceremonies, and observe them carefully to gauge the state of the world and their own state of grace.

In a sense, plateau wildflowers are the way that plants communicate with all of us in "this" realm, enabling us to see who we are and our place in the world. They are models of survival based on timing, cooperation, and adaptability rather than dominance. When we perceive the Colorado Plateau through its flowers, we better understand what sustains as well as what challenges all life here—the dry winds and intense sun, the dual rainy seasons and extreme temperatures, and the intermingling of plants and animals that is the living community itself.

In photosynthesizing sunlight into edible energy, plants form the basis for virtually all other living things. Their flowers lure us across the boundary that we imagine divides us from other forms of life. Coaxing us back into the living landscape after a long cold winter, they radiantly embody the words of John Muir:

The sun shines not on us but in us.

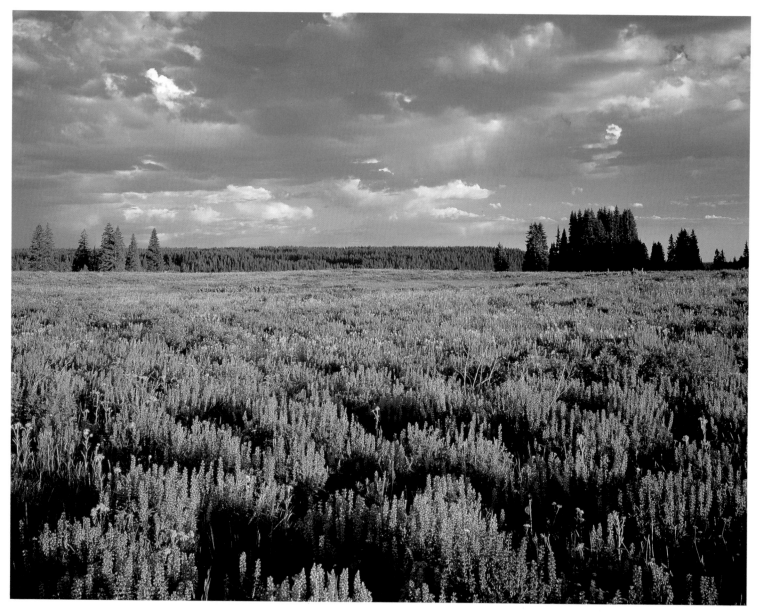

SILVERY LUPINE *Lupinus argenteus*
ORANGE SNEEZEWEED *Helenium hoopesii*
SULPHUR PAINTBRUSH *Castilleja rhexifolia* var. *sulphurea*

Lands End Road, Grand Mesa
Grand Mesa National Forest, Colorado
July 11, 1994

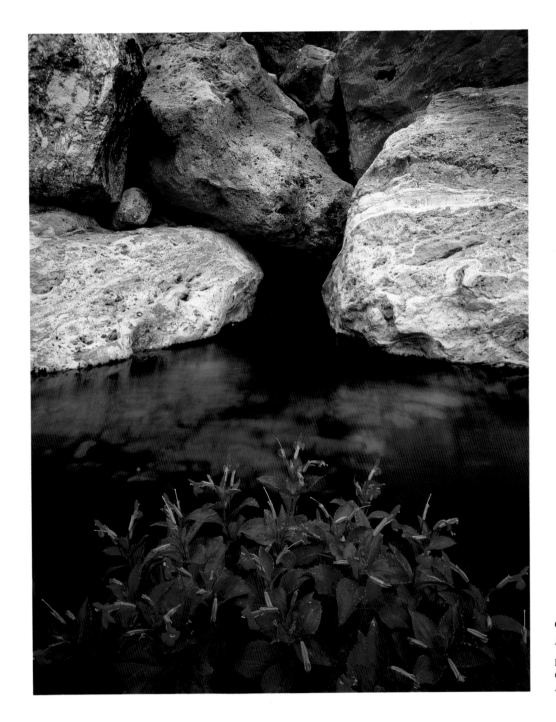

CARDINAL MONKEY-FLOWER
Mimulus cardinalis

Royal Arch Creek, Elves Chasm
Grand Canyon National Park, Arizona
April 12, 1990

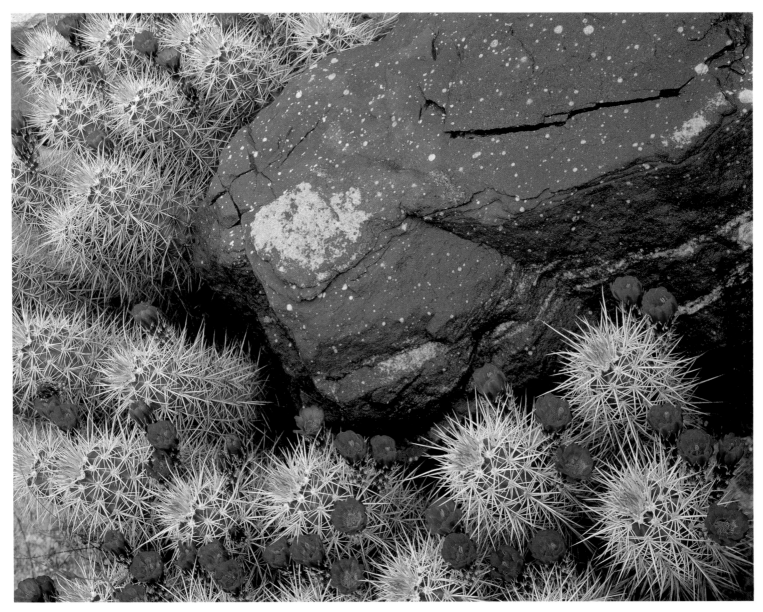

CLARETCUP CACTUS
Echinocereus triglochidiatus var. *melanacanthus*

Middle Granite Gorge, Grand Canyon
Grand Canyon National Park, Arizona
April 13, 1990

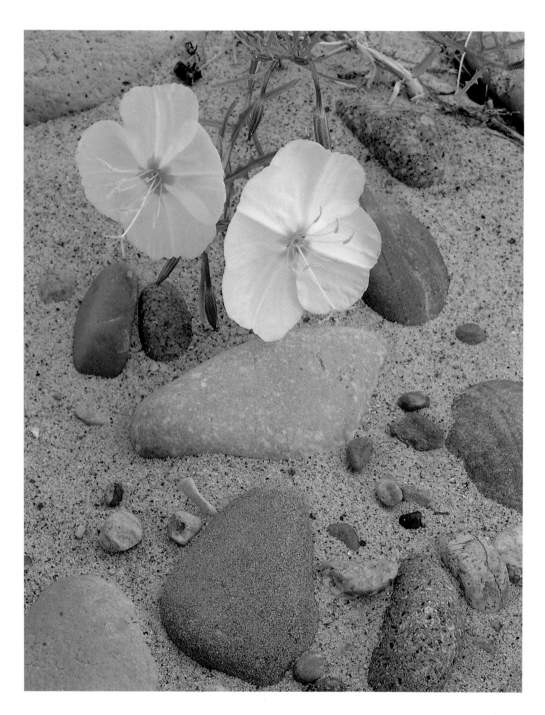

PALE EVENING-PRIMROSE
Oenothera pallida var. *pallida*

Marble Canyon
Grand Canyon National Park, Arizona
April 7, 1990

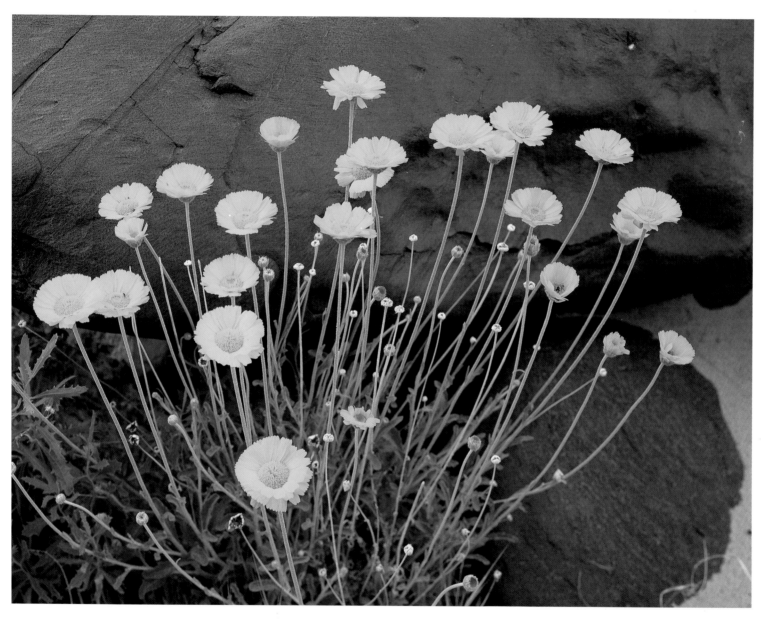

DESERT MARIGOLD
Baileya multiradiata

Below Lava Falls, Grand Canyon
Grand Canyon National Park, Arizona
April 20, 1990

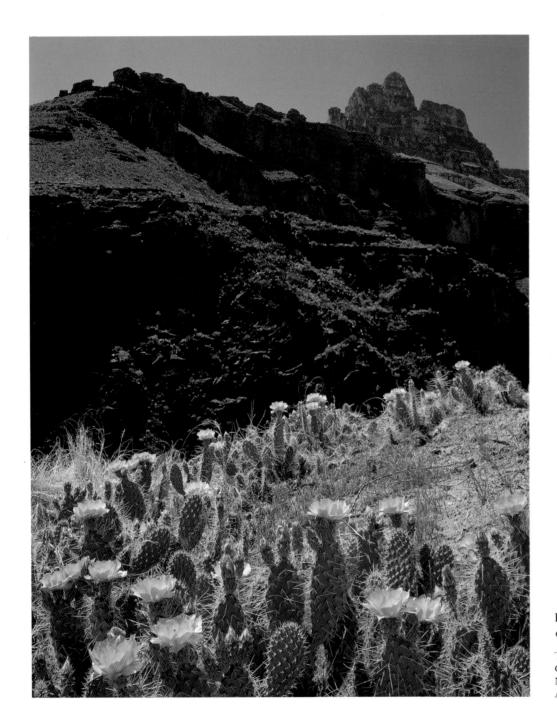

PLAINS PRICKLYPEAR
Opuntia polyacantha var. *nicholii*

Tyndall Dome from the Bass Trail,
Grand Canyon, Grand Canyon
National Park, Arizona
April 11, 1990

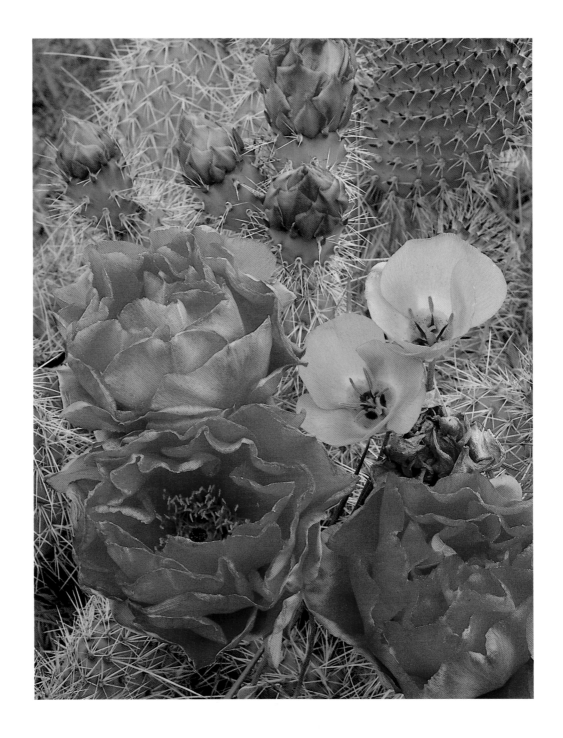

SINUOUS MARIPOSA
Calochortus flexuosus
COMMON PRICKLYPEAR
Opuntia erinacea

La Verkin Overlook Trail
Hurricane Cliffs
Bureau of Land Management
Dixie Resource Area, Utah
April 28, 1995

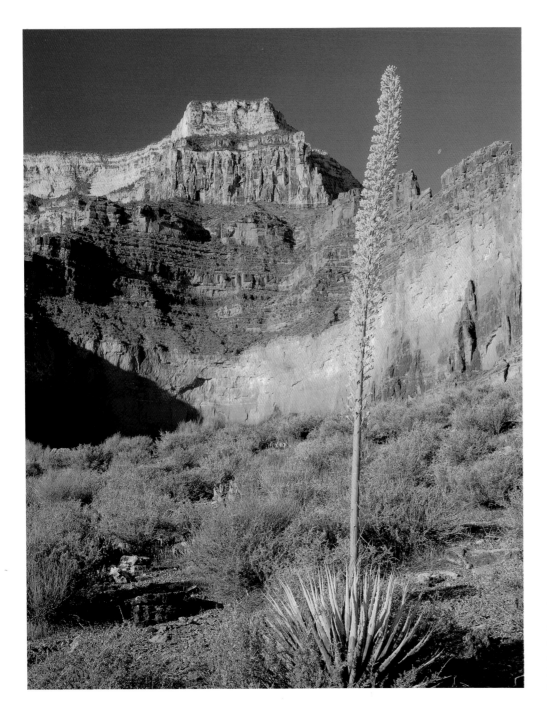

UTAH CENTURY-PLANT
Agave utahensis

Tonto West Trail below Pima Point
Grand Canyon, Grand Canyon
National Park, Arizona
April 4, 1986

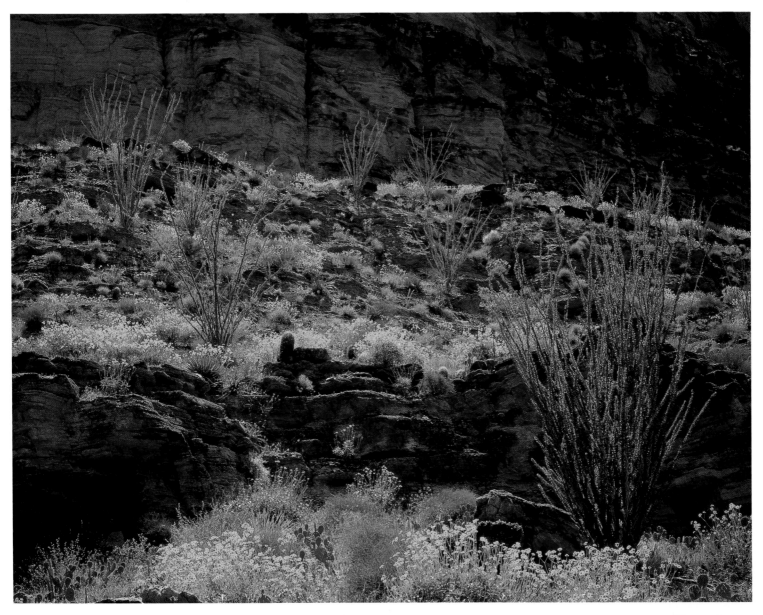

BRITTLEBUSH *Encelia farinosa*
OCOTILLO *Fouquieria splendens* ssp. *splendens*

Havasu Canyon
Grand Canyon National Park, Arizona
April 21, 1993

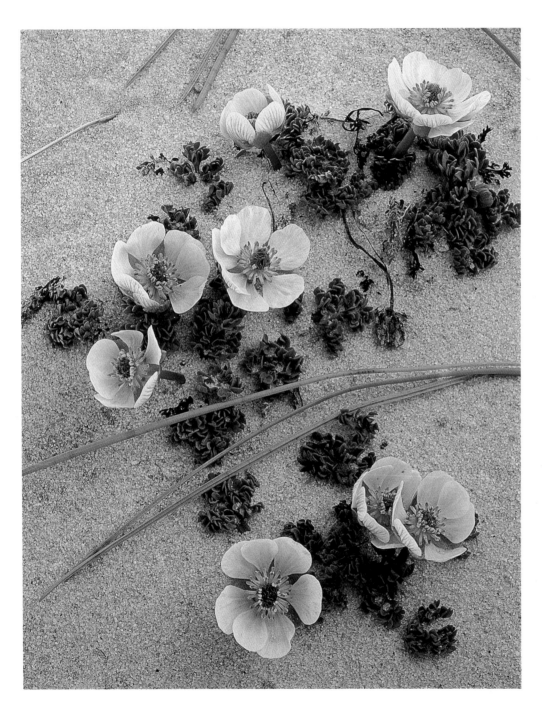

VIOLET BUTTERCUP
Ranunculus andersonii var. *juniperinus*

Pine Creek Canyon
Zion-Mt. Carmel Highway
Zion National Park, Utah
April 25, 1984

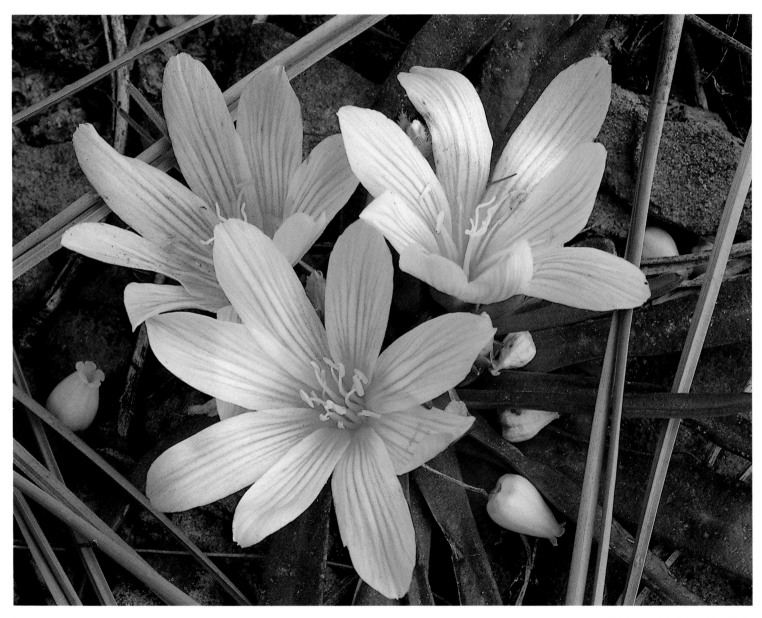

SHOWY LEWISIA
Lewisia brachycalyx
~ AMID PONDEROSA PINE NEEDLES

Highway 87, Mogollon Rim
Coconino National Forest, Arizona
April 3, 1995

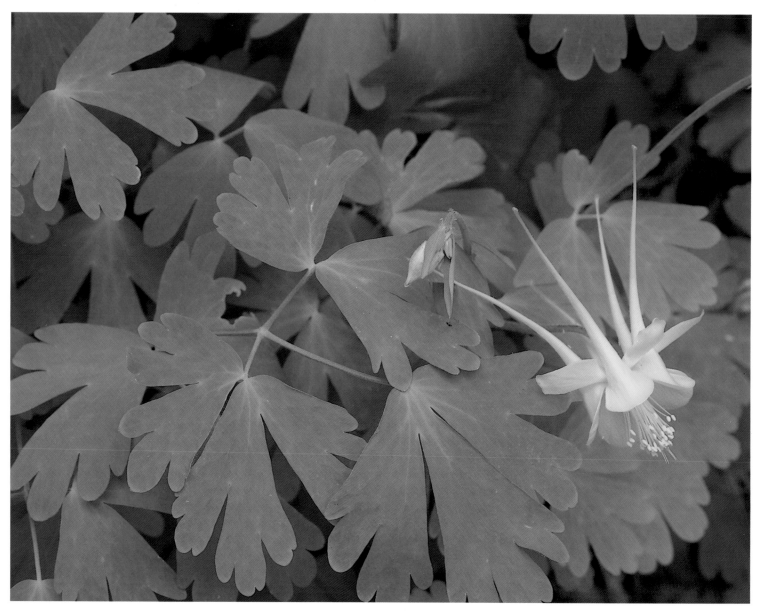

GOLDEN COLUMBINE
Aquilegia chrysantha

Travertine Canyon, Grand Canyon
Grand Canyon National Park, Arizona
April 23, 1990

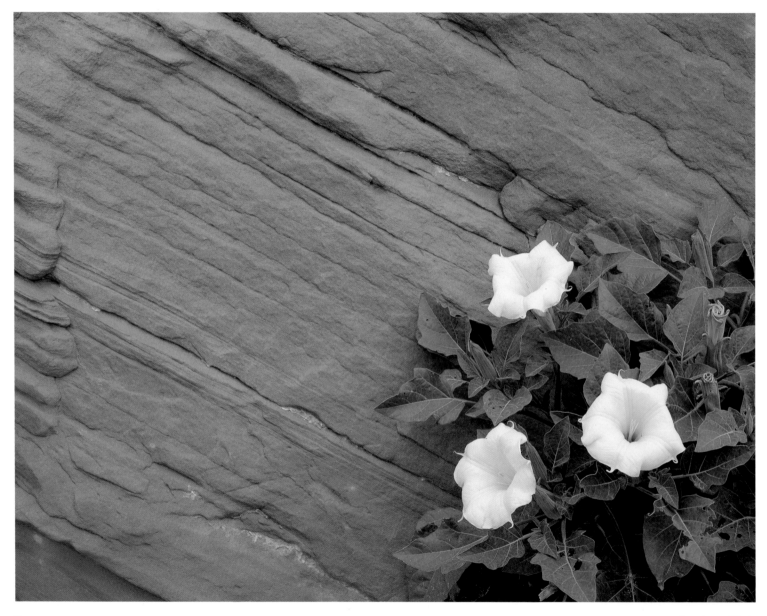

JIMSON WEED
Datura wrightii

Antelope Wash
Navajo Indian Reservation, Arizona
April 25, 1986

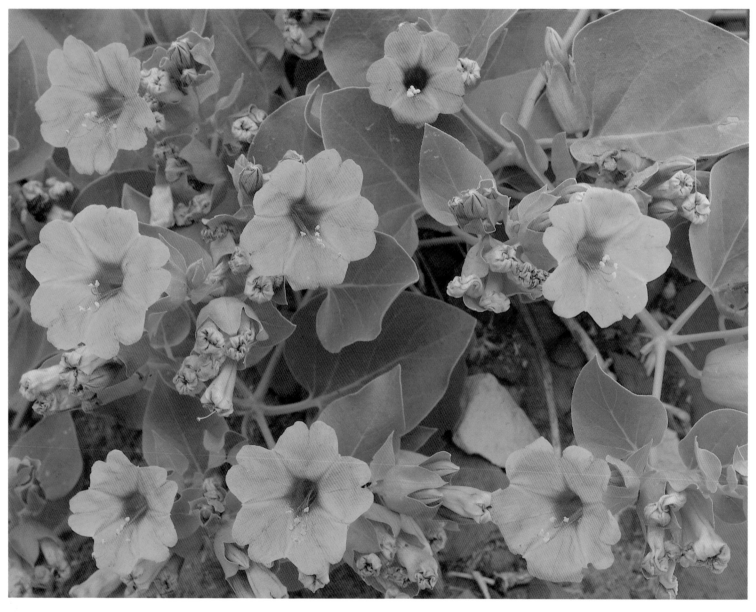

SHOWY FOUR–O'CLOCK
Mirabilis multiflora

Marble Canyon
Grand Canyon National Park, Arizona
April 28, 1986

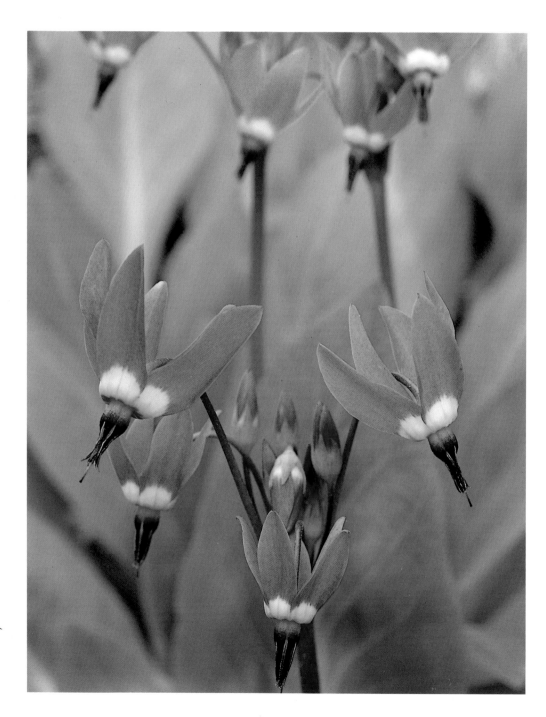

ZION OR PRETTY SHOOTING STAR
Dodecatheon pulchellum var. *Zionense*

Along Pine Creek
Zion National Park, Utah
April 26, 1995

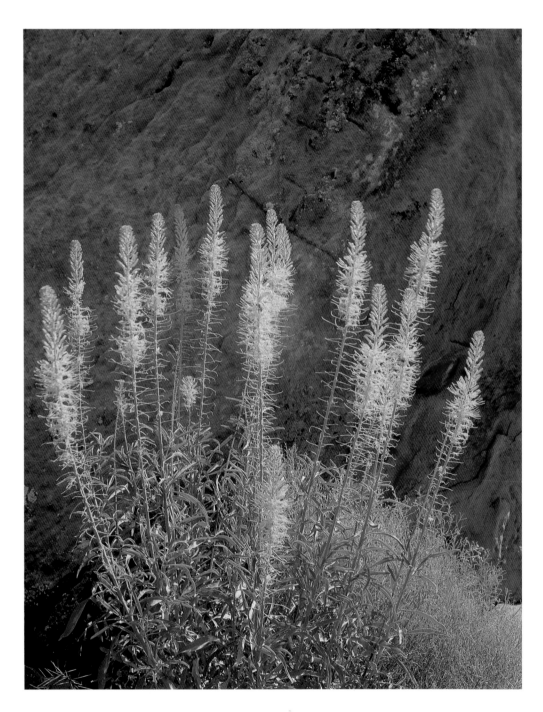

PRINCE'S PLUME
Stanleya pinnata

Zion Canyon
Zion National Park, Utah
April 26, 1986

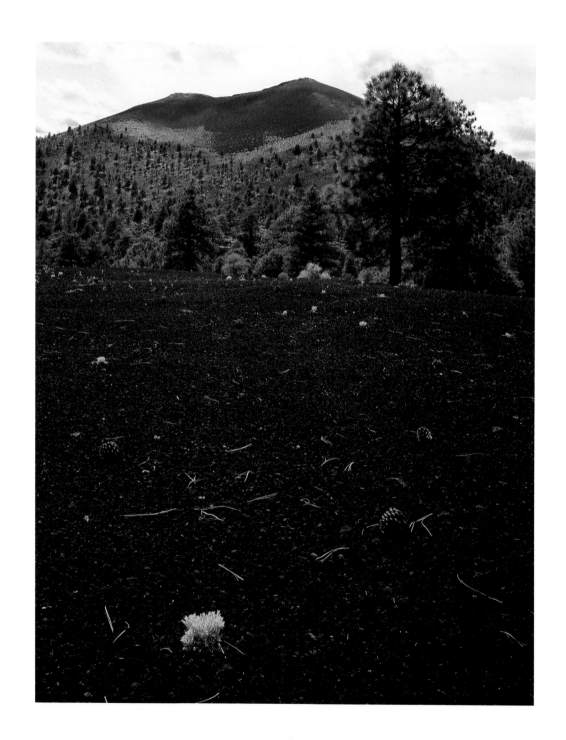

NEWBERRY'S TWINPOD
Physaria newberryi
~ WITH PONDEROSA PINES

Sunset Crater
Coconino National Forest, Arizona
April 30, 1995

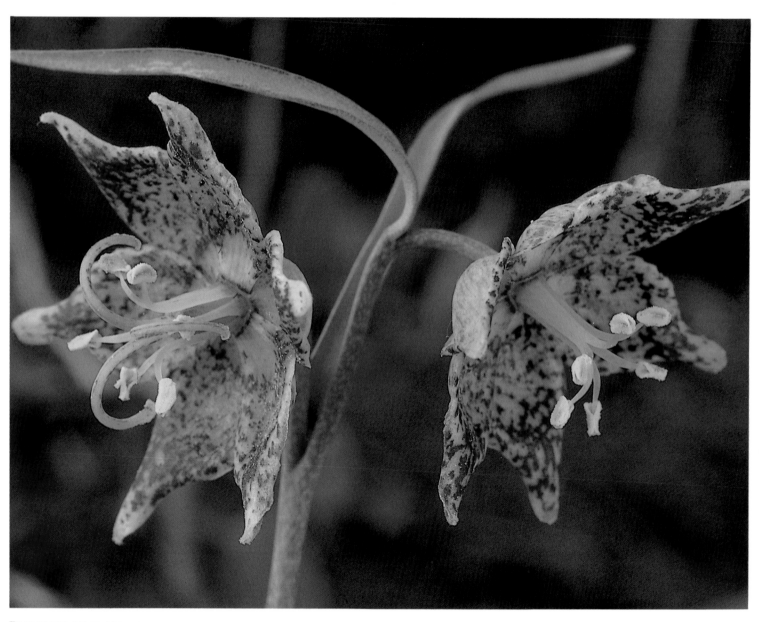

PURPLESPOT FRITILLARY
Fritillaria atropurpurea

Clear Creek Canyon, Zion–Mt. Carmel Highway
Zion National Park, Utah
April 29, 1995

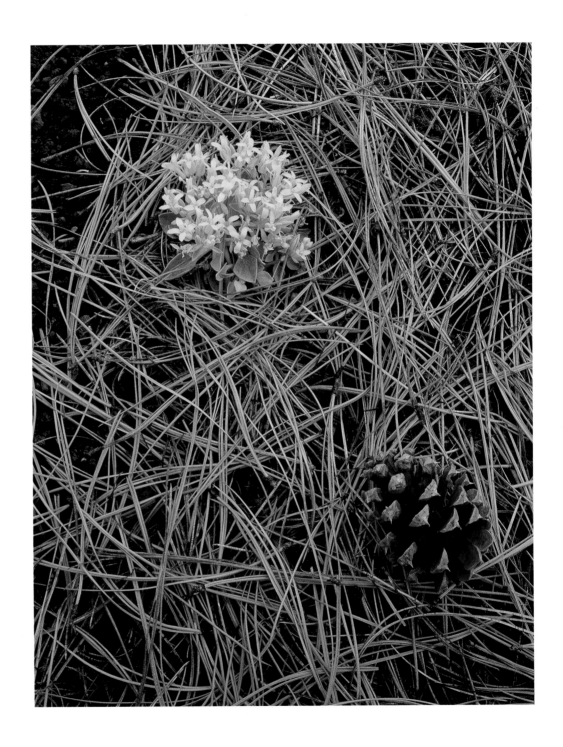

NEWBERRY'S TWINPOD
Physaria newberryi
~ WITH PONDEROSA PINE CONES

Sunset Crater National Monument
Arizona
April 30, 1995

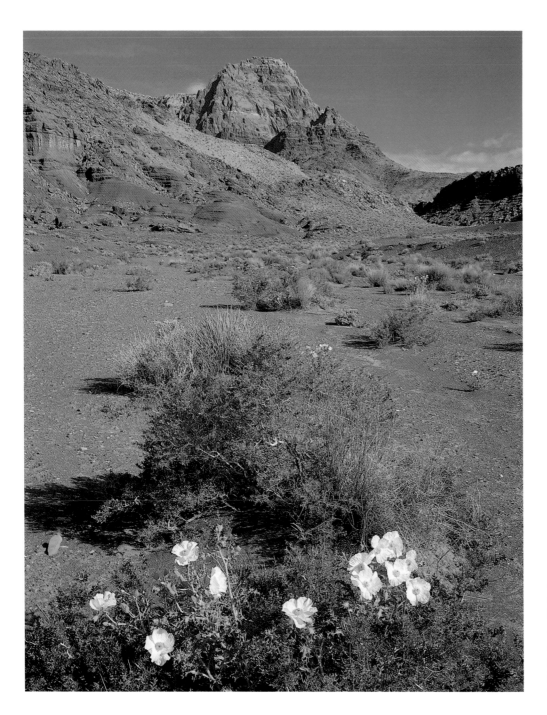

ARMED PRICKLY–POPPY
Argemone munita
BEAUTY INDIGO–BUSH
Psorothamnus arborescens var. *pubescens*

Vermilion Cliffs near Lees Ferry
Glen Canyon National
Recreation Area, Arizona
April 30, 1995

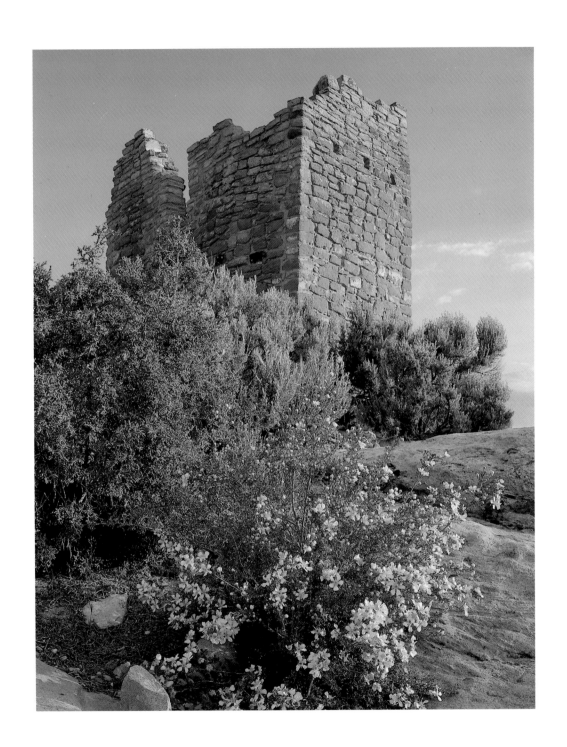

CLIFFROSE
Purshia mexicana var. *stansburyana*

Hovenweep Castle
Hovenweep National
Monument, Utah
May 6, 1992

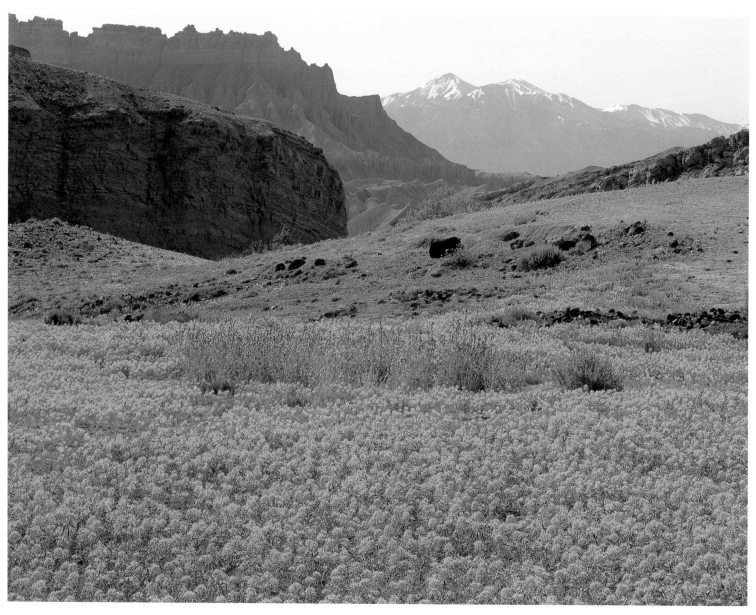

YELLOW BEEPLANT *Cleome lutea*
NELSON'S GLOBEMALLOW *Sphaeralcea parvifolia*

Highway 24, Fremont River Valley
Bureau of Land Management
Henry Mountains Resource Area, Utah
May 4, 1992

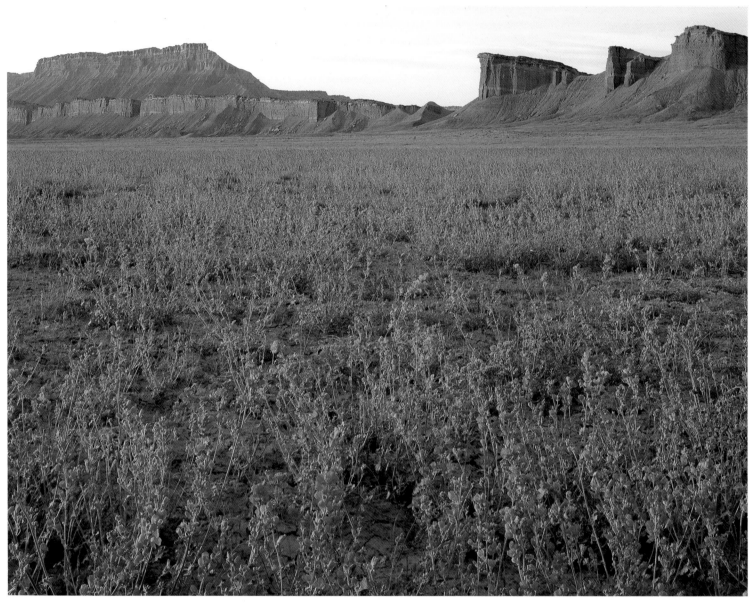

NELSON'S GLOBEMALLOW
Sphaeralcea parvifolia

Swap Mesa, Notom–Bullfrog Road
Bureau of Land Management
Henry Mountains Resource Area, Utah
May 4, 1992

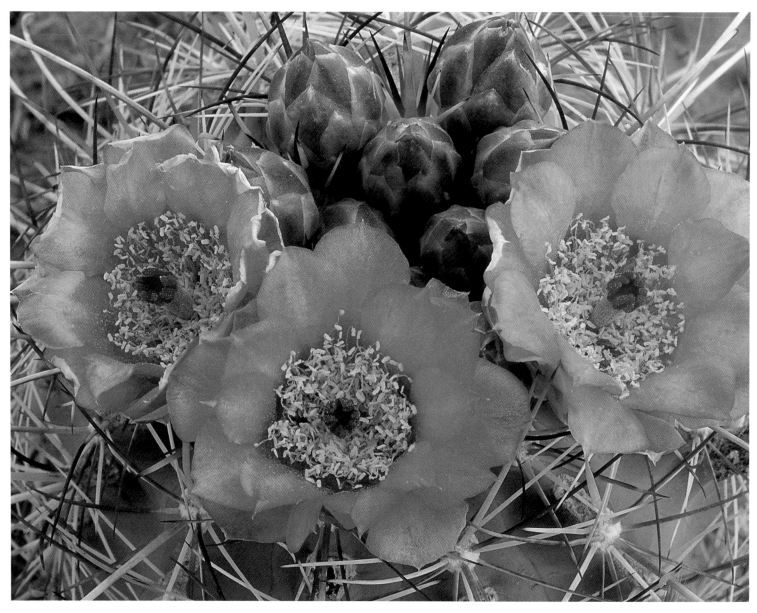

WHIPPLE'S FISHHOOK
Sclerocactus whipplei var. *roseus*

Needles District
Canyonlands National Park, Utah
May 9, 1995

48

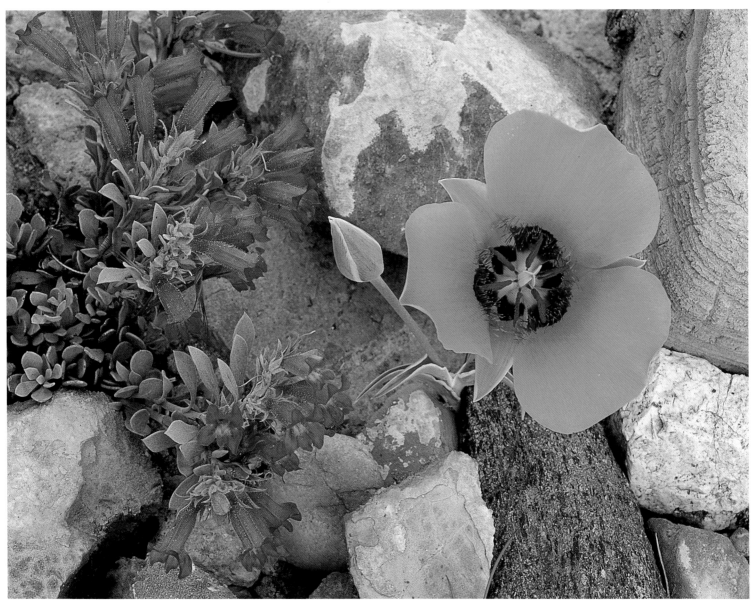

KENNEDY'S MARIPOSA *Calochortus kennedyi*
THOMPSON'S PENSTEMON *Penstemon thompsoniae*

<div align="right">

Peach Springs Canyon
Hualapai Indian Reservation, Arizona
May 4, 1995

</div>

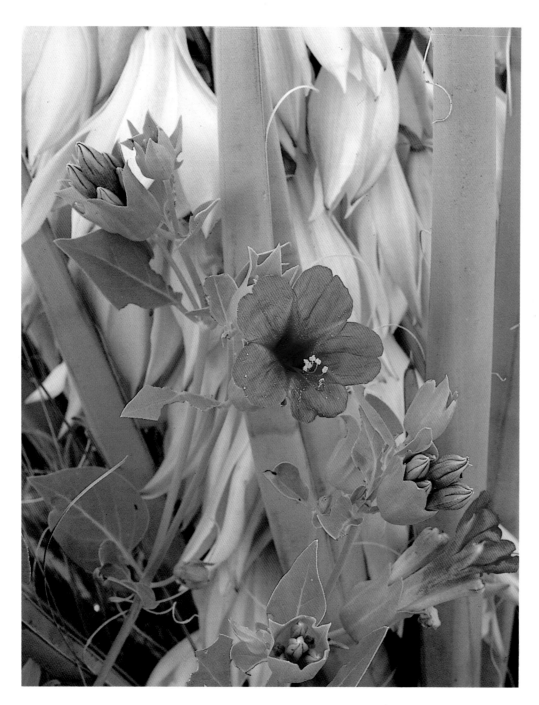

SHOWY FOUR-O'CLOCK
Mirabilis multiflora
BANANA YUCCA
Yucca baccata

Peach Springs Canyon
Hualapai Indian Reservation, Arizona
May 4, 1995

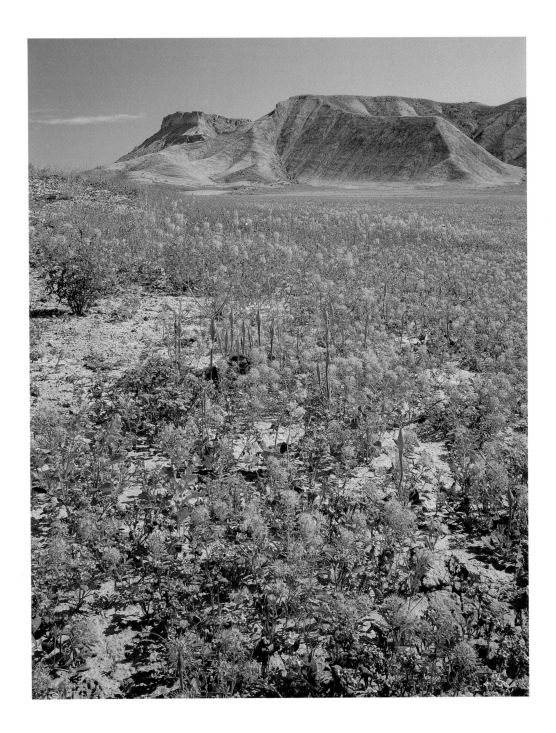

PRETTY PHACELIA
Phacelia pulchella var. *sabulonum*
YELLOW BEEPLANT
Cleome lutea
EASTWOOD'S CAMISSONIA
Camissonia eastwoodiae
DESERT TRUMPET
Eriogonum inflatum

Blue Flats, Highway 24
Bureau of Land Management
Henry Mountains Resource Area, Utah
May 4, 1995

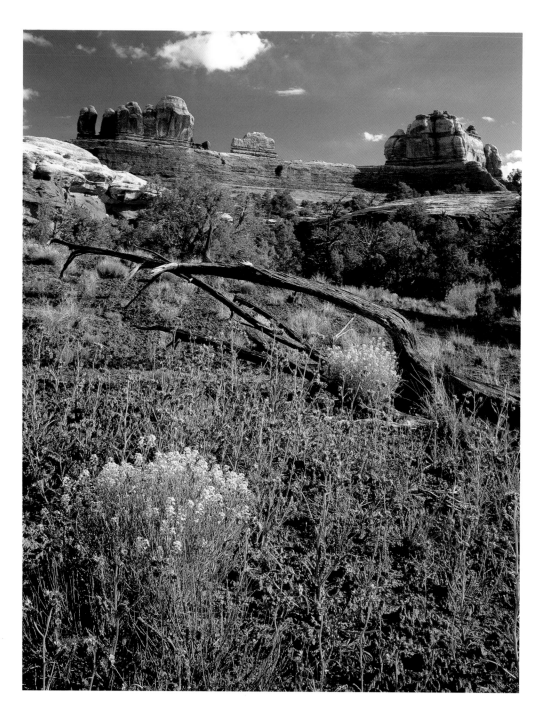

CRENULATE PHACELIA
Phacelia crenulata var. *corrugata*
DWARF LUPINE
Lupinus pusillus var. *pusillus*
MOUNTAIN PEPPERPLANT
Lepidium montanum var. *jonesii*

Squaw Canyon
Wooden Shoe Arch, Needles District
Canyonlands National Park, Utah
May 8, 1995

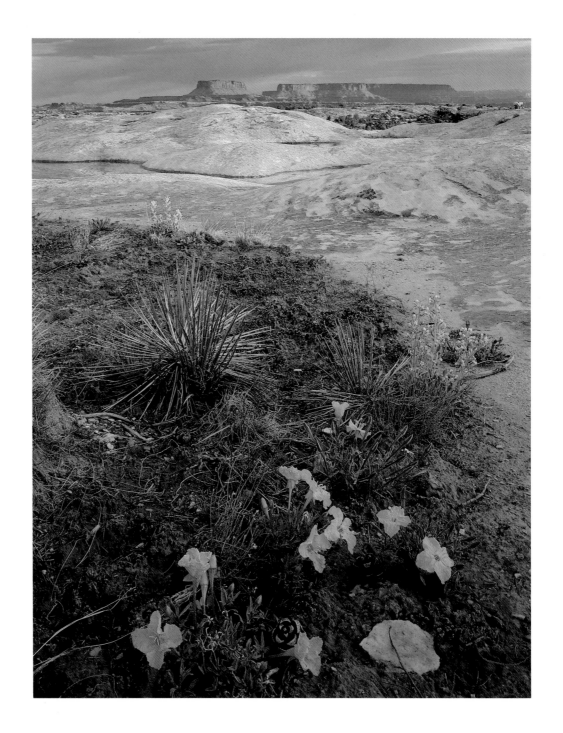

LAVENDERLEAF
EVENING–PRIMROSE
Calylophus lavandulifolius
YELLOW–EYED CRYPTANTH
Cryptantha flavoculata

Pothole Point, Needles District
Canyonlands National Park, Utah
May 10, 1995

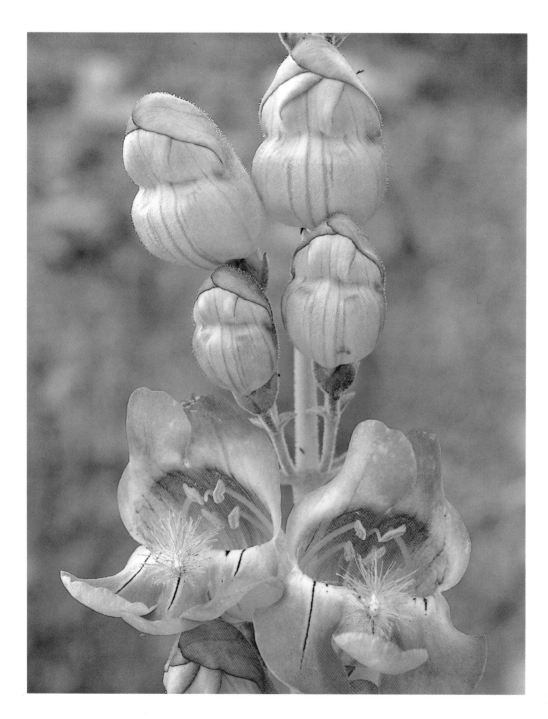

PALMER'S PENSTEMON
Penstemon palmeri var. *palmeri*

Peach Springs Canyon
Hualapai Indian Reservation, Arizona
May 4, 1995

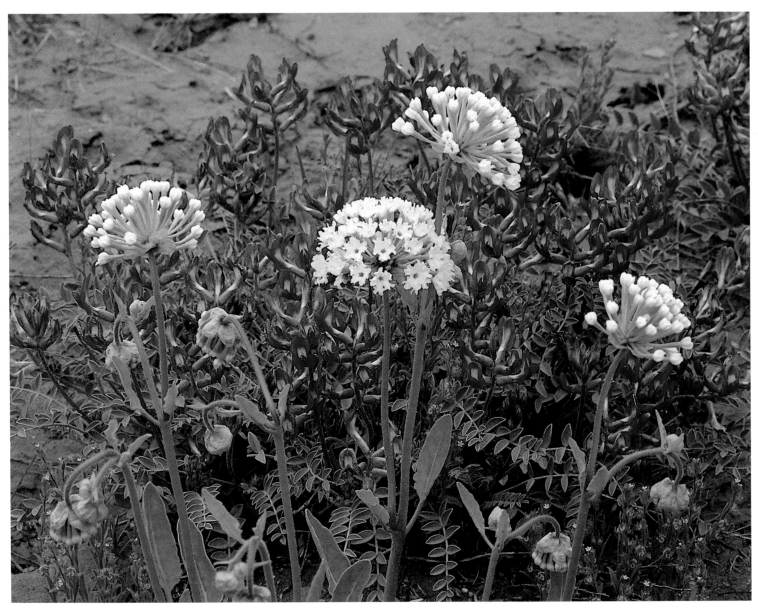

FRAGRANT SAND-VERBENA *Abronia fragrans*
CRESCENT MILKVETCH *Astragalus amphioxys* var. *amphioxys*

Highway 44
Zia Indian Reservation, New Mexico
May 11, 1995

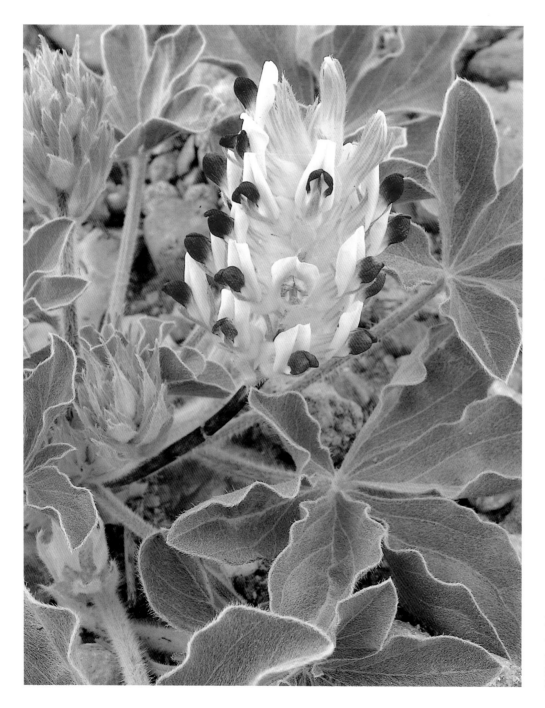

PEACH SPRINGS BREADROOT
Pediomelum retrorsum

Peach Springs Canyon
Hualapai Indian Reservation, Arizona
May 3, 1995

GREAT BLADDERY MILKVETCH
Astragalus megacarpus
~ AMID PONDEROSA PINE CONES

Cooks Ranch Trail
Bryce Canyon
Bryce Canyon National Park
Paunsaugunt Plateau, Utah
May 18, 1995

ENGELMANN HEDGEHOG–CACTUS
Echinocereus engelmannii

Peach Springs Canyon
Hualapai Indian Reservation, Arizona
May 3, 1995

COMMON PAINTBRUSH
Castilleja chromosa
STEMLESS WOOLLYBASE
Hymenoxys acaulis var. *ivesiana*

Highway 95
Dirty Devil River Arm of Lake Powell
Glen Canyon National Recreation Area, Utah
May 6, 1995

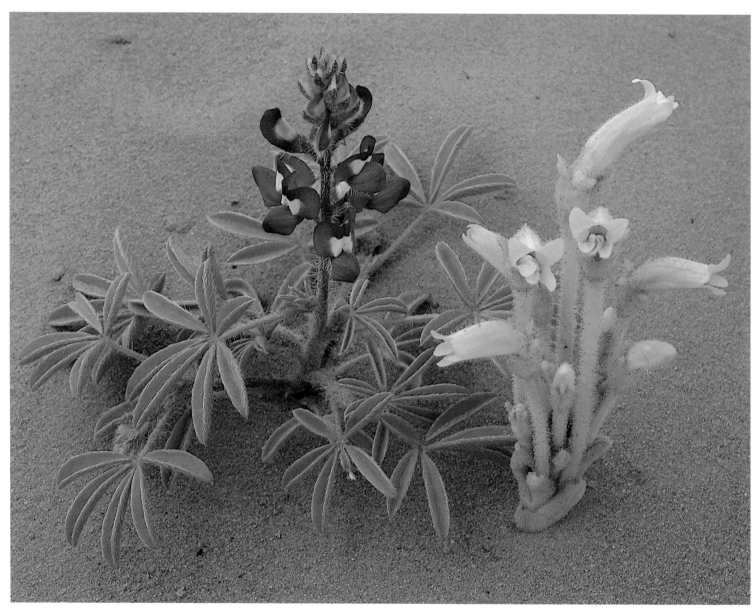

DWARF LUPINE *Lupinus pusillus* var. *pusillus*
BROOMRAPE *Orobanche fasciculata* var. *lutea*

Highway 95, North Wash
Bureau of Land Management
Henry Mountains Resource Area, Utah
May 6, 1995

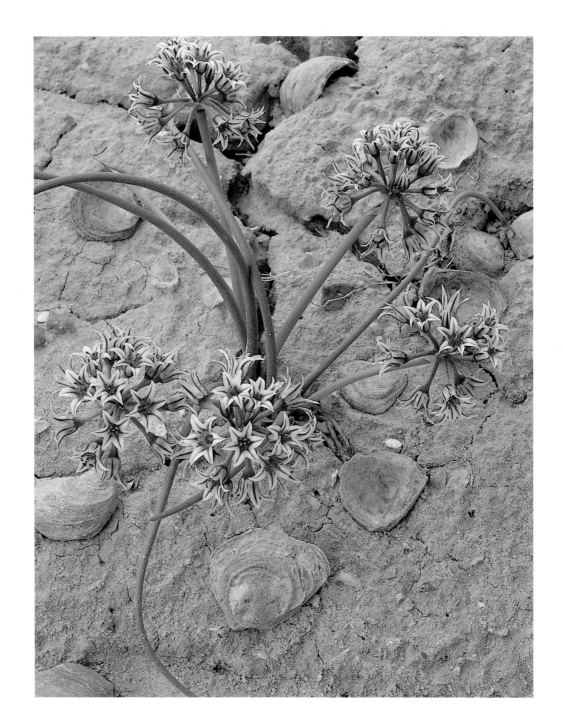

SAN JUAN ONION
Allium macropetalum
~ WITH FOSSILIZED OYSTER SHELLS

Notom Cutoff Road, Blue Flats
Bureau of Land Management
Henry Mountains Resource Area, Utah
May 7, 1995

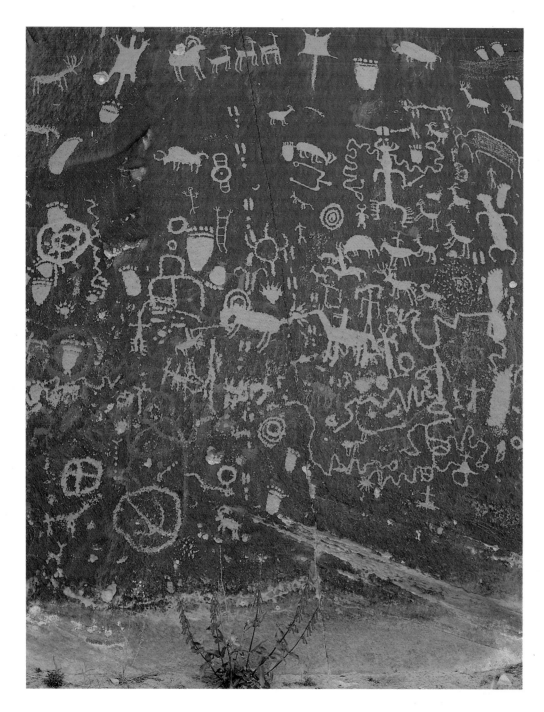

SCARLET–BUGLER PENSTEMON
Penstemon eatonii var. *eatonii*

Petroglyphs on Newspaper Rock
Indian Creek Canyon
Newspaper Rock State Park, Utah
May 13, 1992

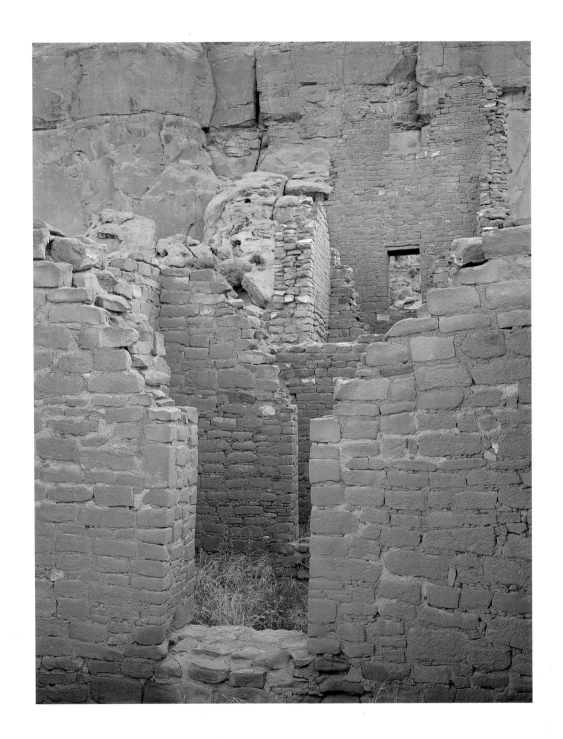

NARROWLEAF PENSTEMON

Penstemon angustifolius

Kin Kletso, Chaco Canyon
Chaco Culture National Historical Park
New Mexico
May 9, 1992

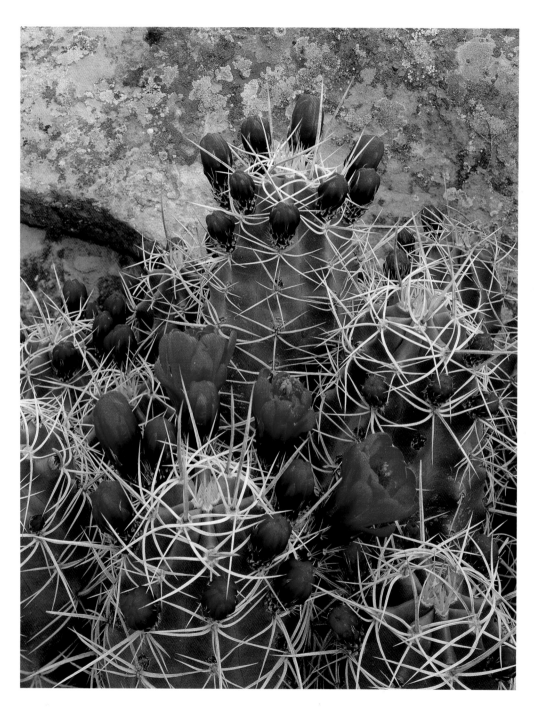

CLARETCUP CACTUS
Echinocereus triglochidiatus var. *melanacanthus*

near Wijiji Ruin, Chaco Canyon
Chaco Culture National Historical Park
New Mexico
May 8, 1992

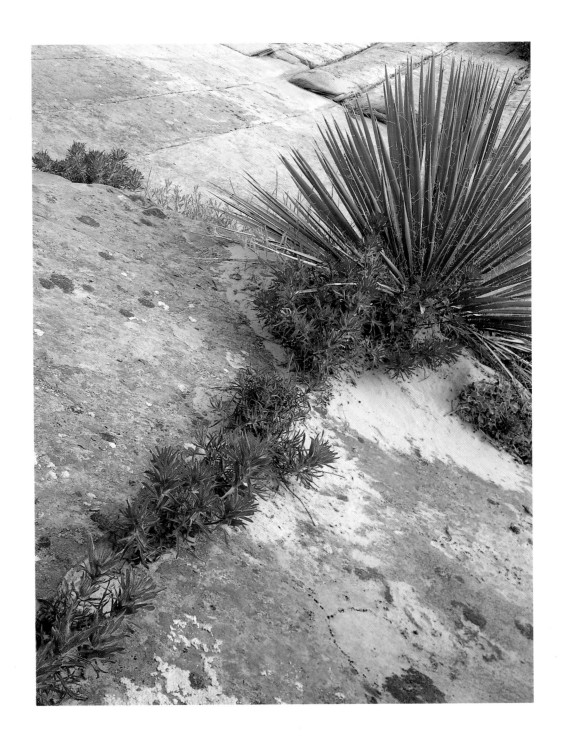

SLICKROCK PAINTBRUSH
Castilleja scabrida var. *scabrida*
UTAH YUCCA
Yucca utahensis

Clear Creek Canyon
Zion-Mt. Carmel Highway
Zion National Park, Utah
April 28, 1995

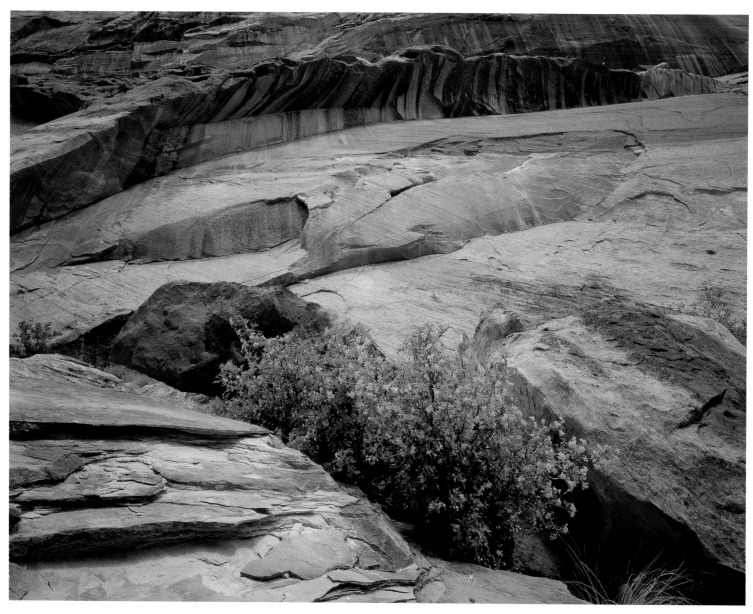

FREMONT'S MAHONIA
Mahonia fremontii

Capitol Wash
Capitol Reef National Park, Utah
May 7, 1995

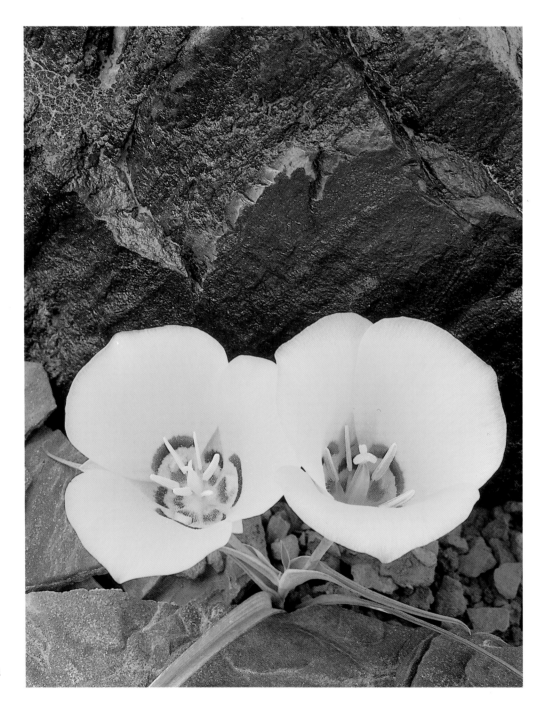

GOLDEN MARIPOSA
Calochortus aureus
~ AGAINST PETRIFIED WOOD

Wolverine Petrified Wood Natural Area
Wolverine Loop Road, Bureau of Land
Management Escalante Resource Area, Utah
May 19, 1995

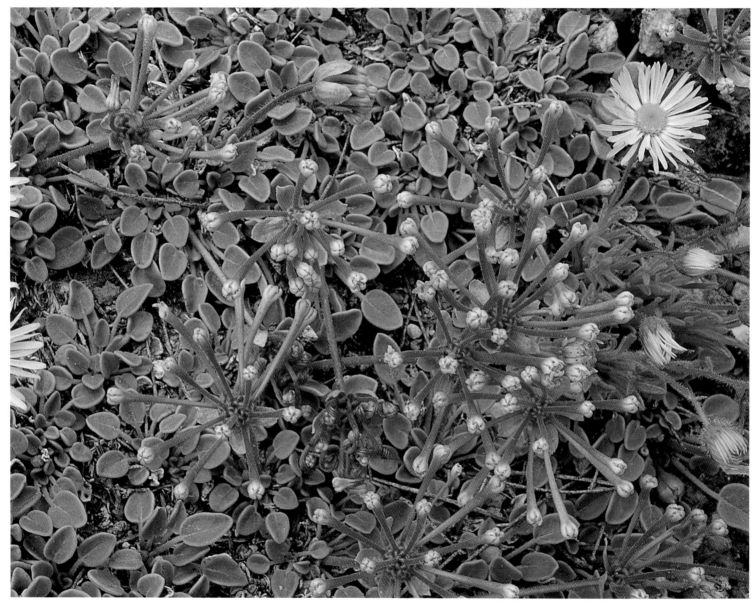

LOW SAND-VERBENA *Abronia nana*
LOW FLEABANE *Erigeron pumilus*

Wolverine Loop Road
Bureau of Land Management
Escalante Resource Area , Utah
May 19, 1995

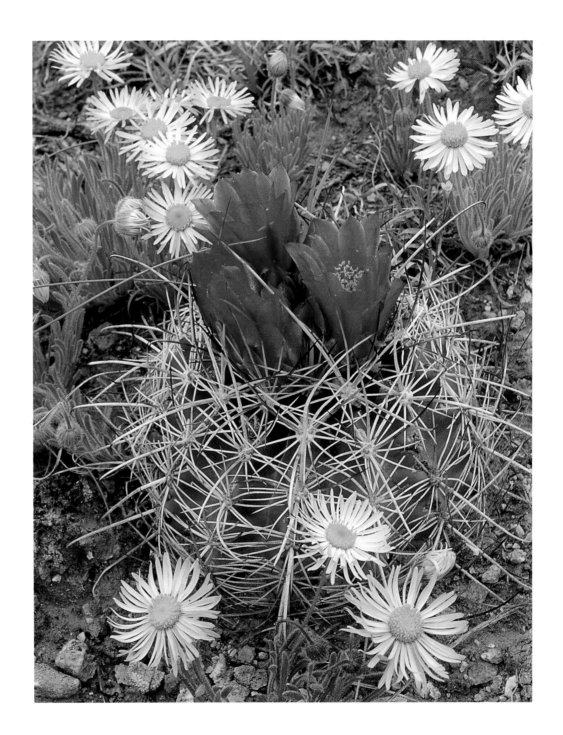

LOW FLEABANE
Erigeron pumilus
WHIPPLE'S FISHHOOK
Sclerocactus whipplei var. *roseus*

Wolverine Loop Road
Bureau of Land Management
Escalante Resource Area, Utah
May 19, 1995

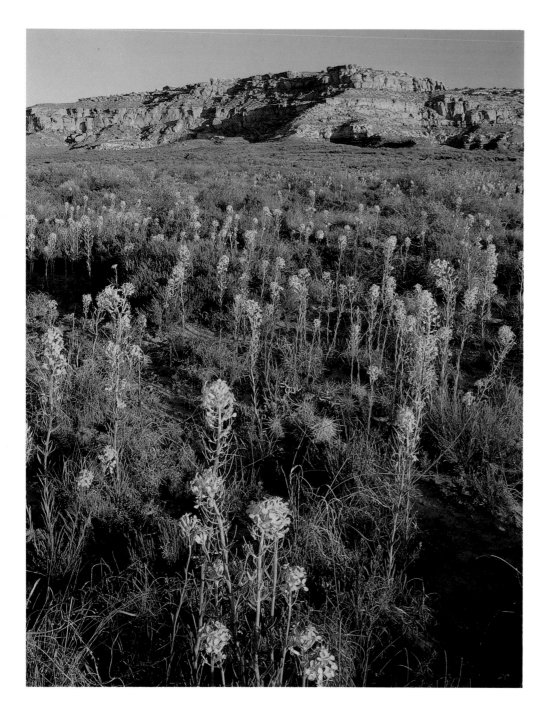

WESTERN WALLFLOWER
Erysimum asperum

Chaco Canyon
Chaco Culture National Historical Park
New Mexico
May 14, 1995

FENDLER'S BLADDER–POD
Lesquerella fendleri

Chaco Canyon
Chaco Culture National Historical Park
New Mexico
May 14, 1995

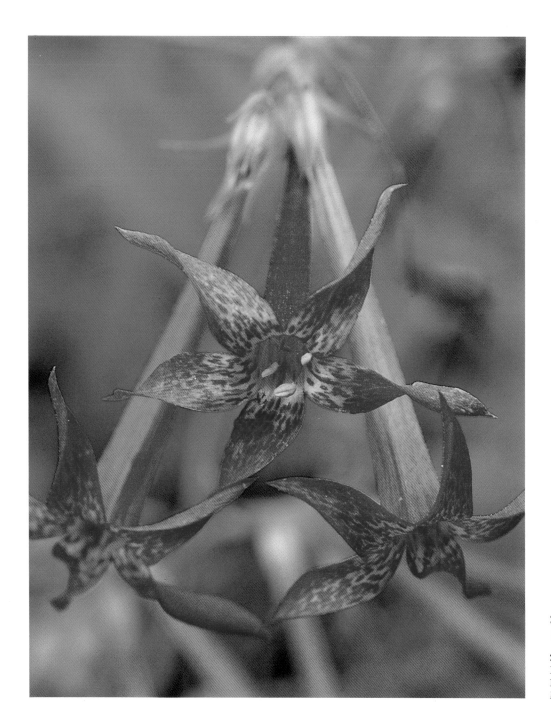

SCARLET GILIA
Gilia aggregata

Sand Canyon
Echo Park Road
Dinosaur National Monument, Colorado
May 31, 1994

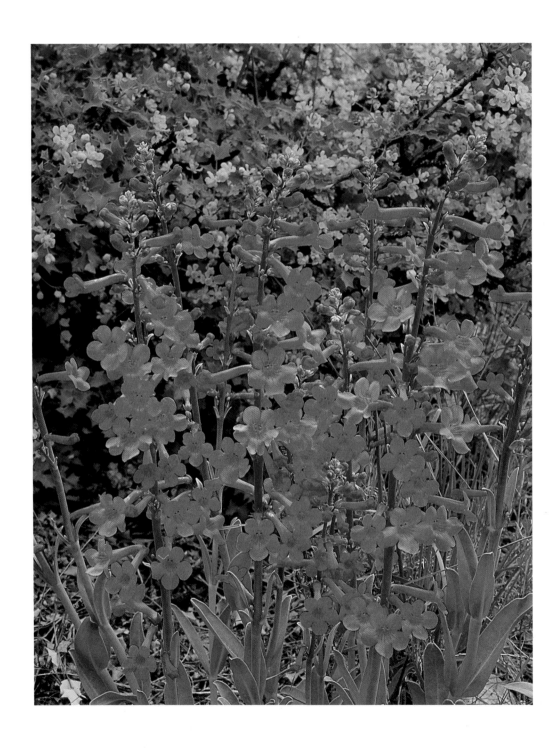

UTAH PENSTEMON
Penstemon utahensis
FREMONT'S MAHONIA
Mahonia fremontii

Scenic Drive, Capitol Wash
Capitol Reef National Park, Utah
May 20, 1995

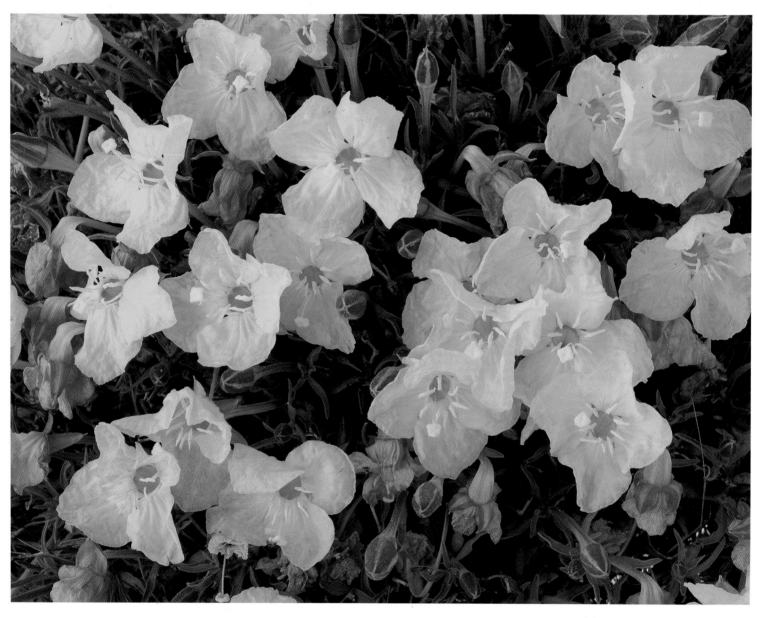

LAVENDERLEAF EVENING-PRIMROSE
Calylophus lavandulifolius

Natural Bridges National Monument, Utah
May 18, 1994

ROUGH MULESEARS
Wyethia scabra var. *scabra*

Courthouse Towers
Arches National Park, Utah
May 22, 1994

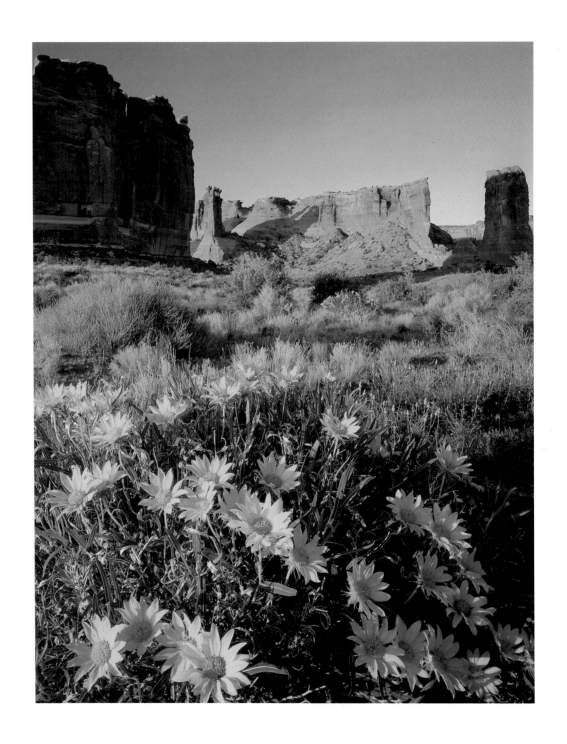

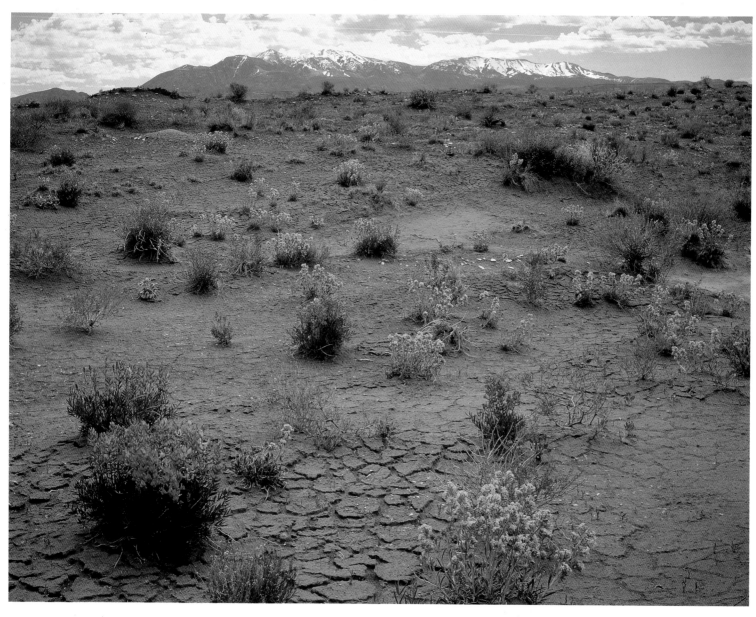

LAMBERT'S LOCOWEED *Oxytropis lambertii*
YELLOW CRYPTANTH *Cryptantha flava*
~ AND THE HENRY MOUNTAINS

Notom–Bullfrog Road
Bureau of Land Management
Henry Mountains Resource Area, Utah
May 20, 1995

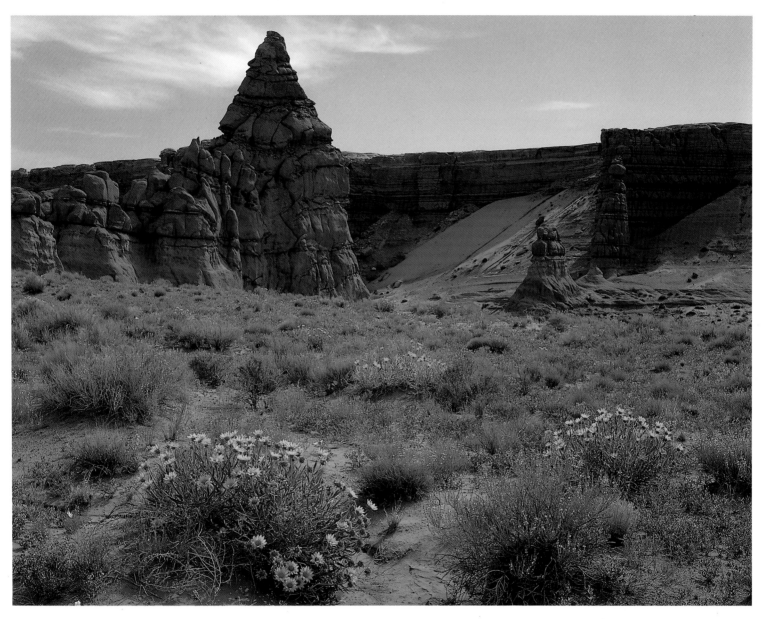

ROUGH MULESEARS *Wyethia scabra* var. *scabra*
PURPLE SAGE *Poliomintha incana*
CRESCENT MILKVETCH *Astragalus amphioxys*

Highway 24 north of Hanksville
Bureau of Land Management
Henry Mountains Resource Area, Utah
May 22, 1995

CARPET PHLOX
Phlox hoodii var. *canescens*

Home Bench
Phipps–Death Hollow
Outstanding Natural Area
Escalante River Basin
Bureau of Land Management
Escalante Resource Area, Utah
May 18, 1995

TUFTED EVENING–PRIMROSE
Oenothera caespitosa var. *marginata*
CRENULATE PHACELIA
Phacelia crenulata var. *corrugata*
~ AND ANTHILL

Bentonite Hills, River Ford Road
Bureau of Land Management
Henry Mountains Resource Area, Utah
May 21, 1995

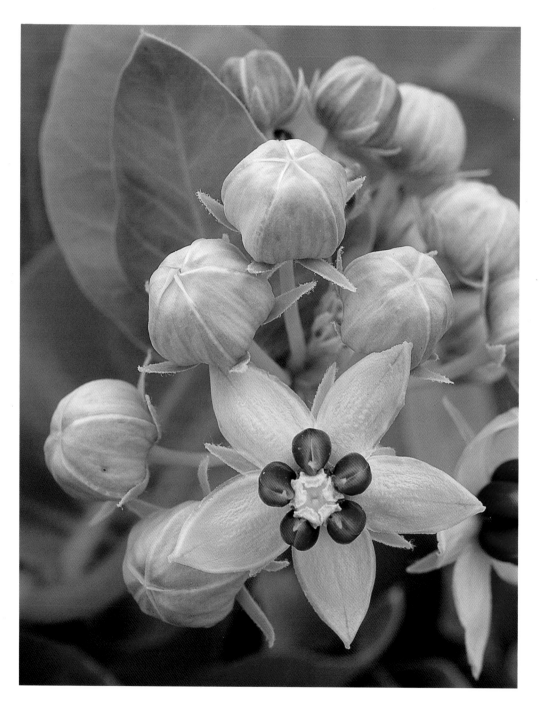

PALLID MILKWEED

Asclepias cryptoceras

La Sal Mountain Loop Road
Manti-La Sal National Forest, Utah
May 21, 1994

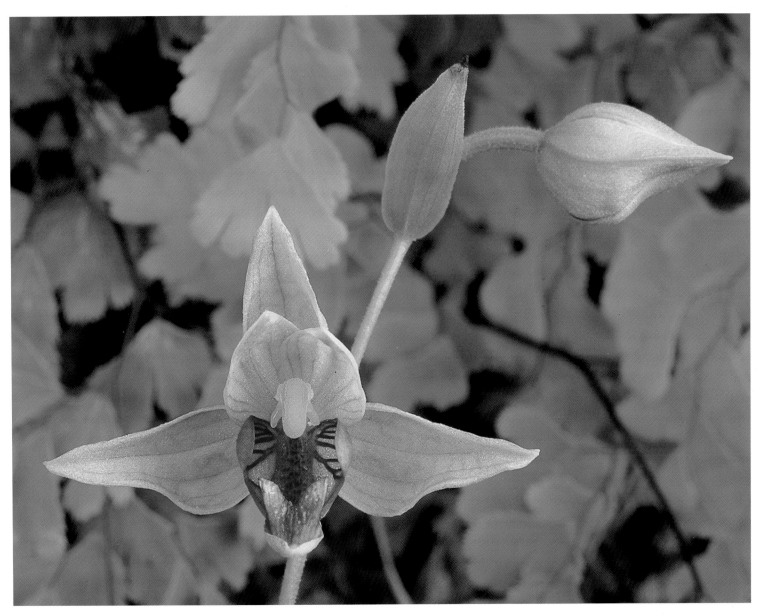

STREAM ORCHID *Epipactis gigantea*

~ WITH MAIDENHAIR FERN

Alcove near trail to Delicate Arch
Arches National Park, Utah
May 22, 1994

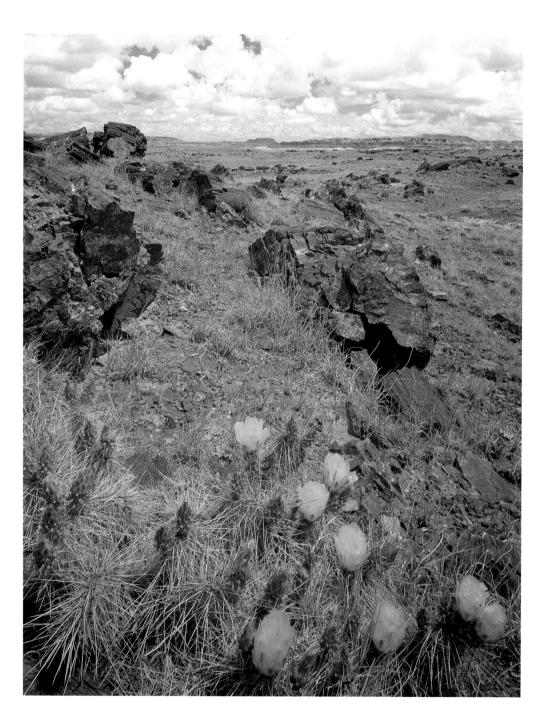

COMMON PRICKLYPEAR
Opuntia erinacea
~ AND PETRIFIED WOOD

Long Logs
Petrified Forest National Park, Arizona
May 25, 1994

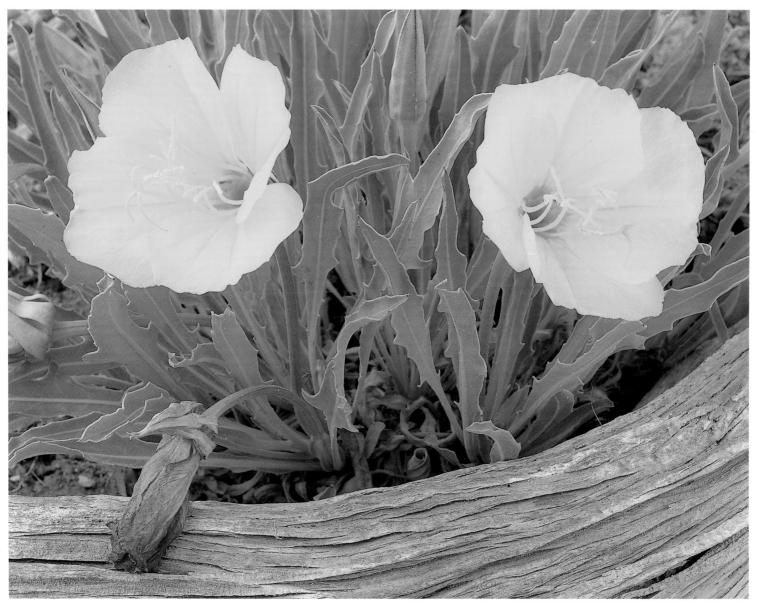

BRONZE EVENING-PRIMROSE
Oenothera howardii

Notom-Bullfrog Road
Bureau of Land Management
Henry Mountains Resource Area, Utah
May 27, 1994

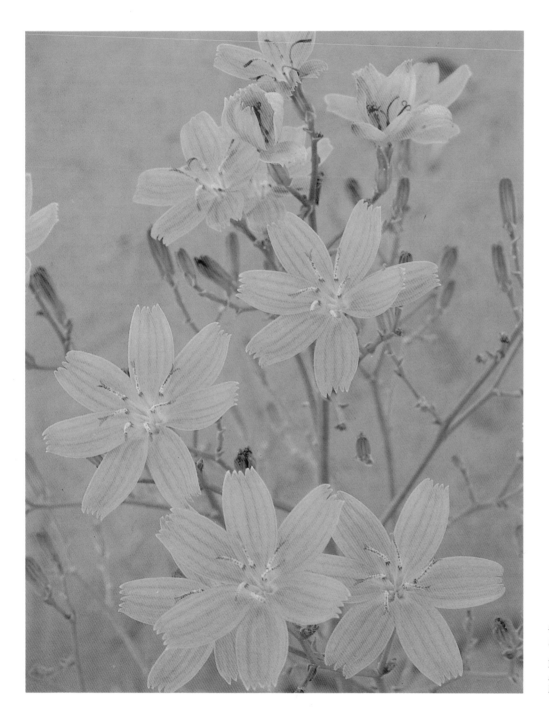

ANNUAL WIRELETTUCE
Stephanomeria exigua

Dune Mesa
Arches National Park, Utah
May 23, 1995

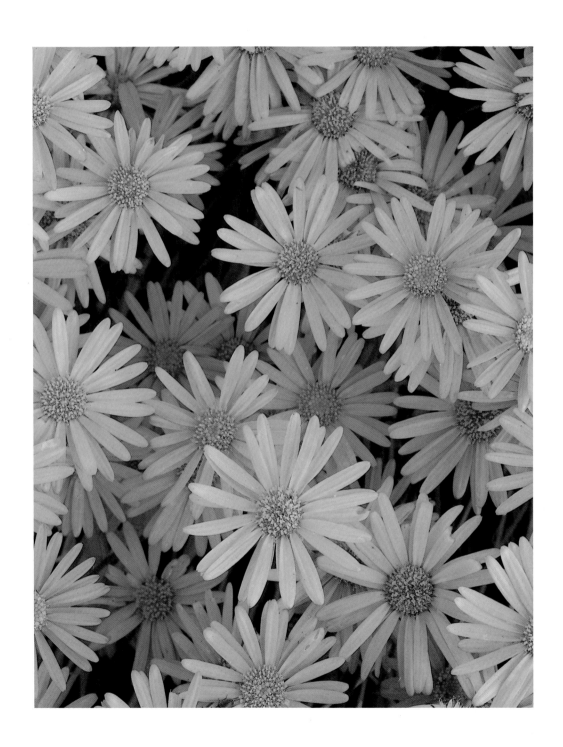

UTAH DAISY
Erigeron utahensis var. *utahensis*

Burr Trail
Capitol Reef National Park, Utah
May 27, 1994

COMMON MONKEY-FLOWER *Mimulus guttatus*
HEARTLEAF BITTERCRESS *Cardamine cordifolia*

Calf Creek, Escalante River Basin
Bureau of Land Management
Escalante Resource Area, Utah
May 25, 1989

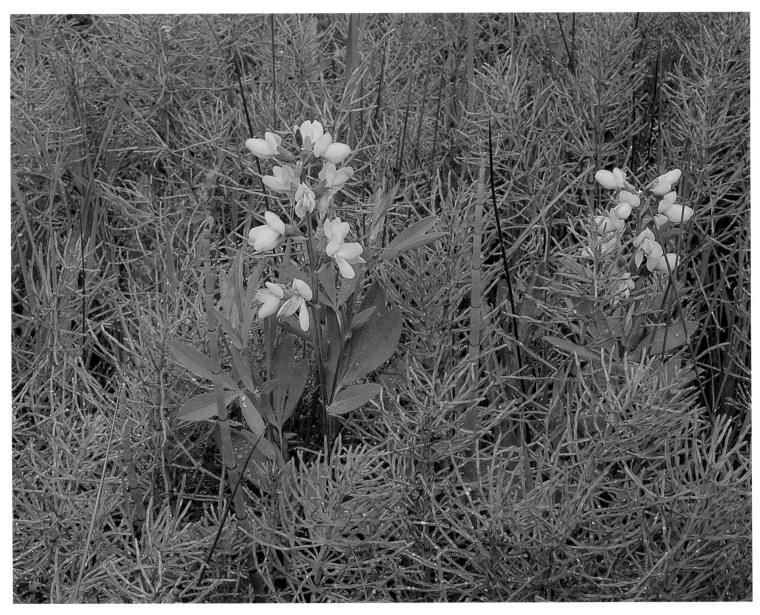

GOLDEN PEA *Thermopsis montana*

~ WITH MEADOW HORSETAIL

Jones Hole Trail, Jones Hole
Dinosaur National Monument, Utah
May 27, 1995

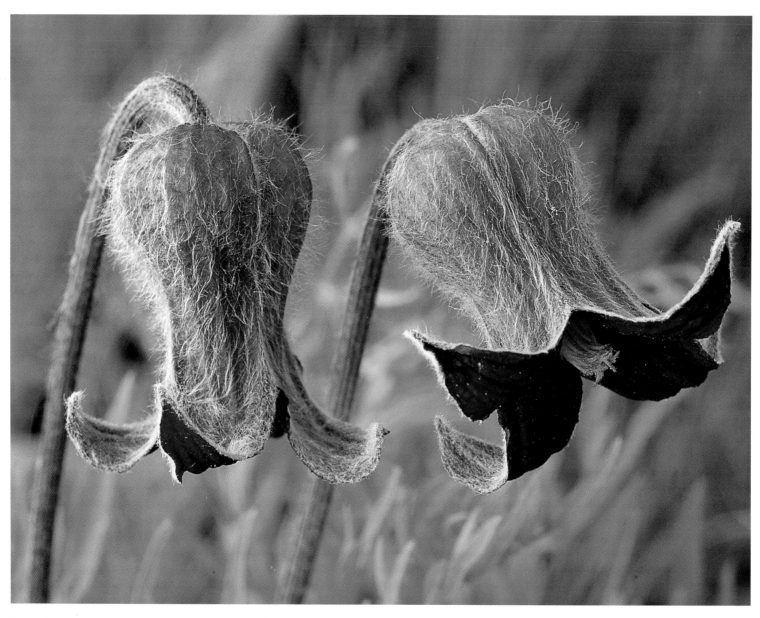

LION'S-BEARD
Clematis hirsutissima

Divide Road, Uncompahgre Plateau
Uncompahgre National Forest, Colorado
May 29, 1994

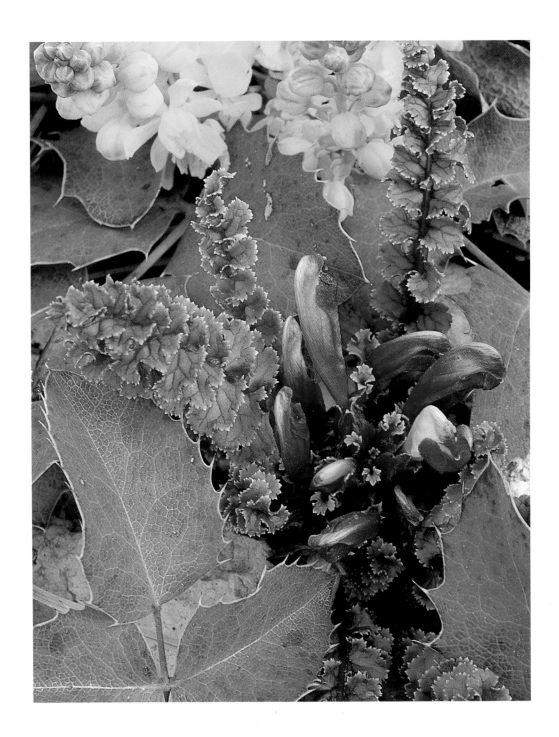

PINYON–JUNIPER LOUSEWORT
Pedicularis centranthera
CREEPING MAHONIA
Mahonia repens

Cooks Ranch Trail
Bryce Canyon
Bryce Canyon National Park
Paunsaugunt Plateau, Utah
May 18, 1995

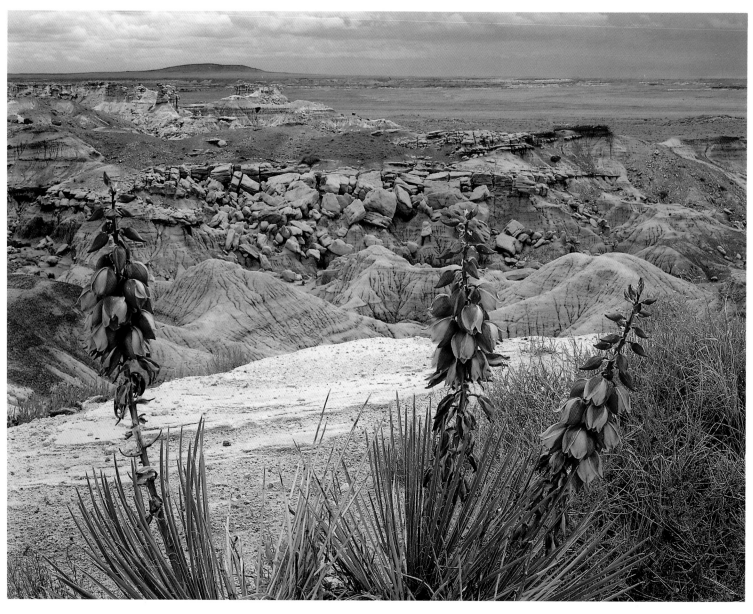

NARROW-LEAVED YUCCA
Yucca angustissima

Blue Mesa
Petrified Forest National Park, Arizona
May 25, 1994

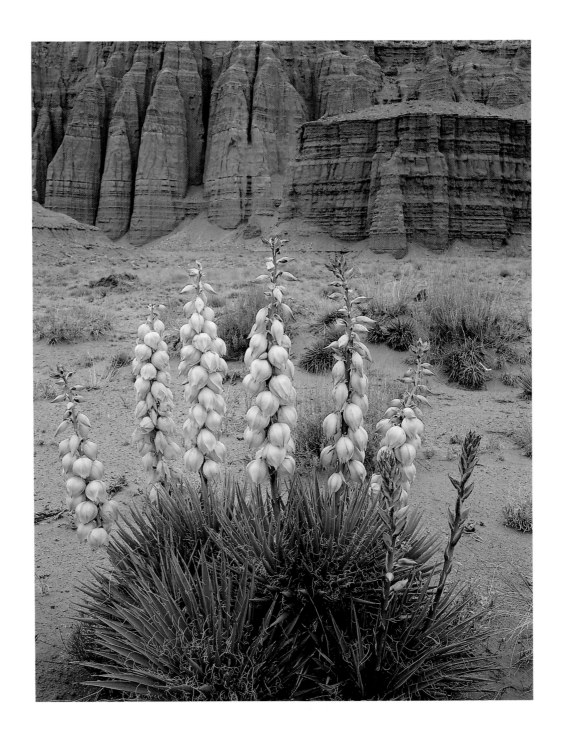

HARRIMAN YUCCA

Yucca harrimaniae

Upper Cathedral Valley
Capitol Reef National Park, Utah
May 28, 1994

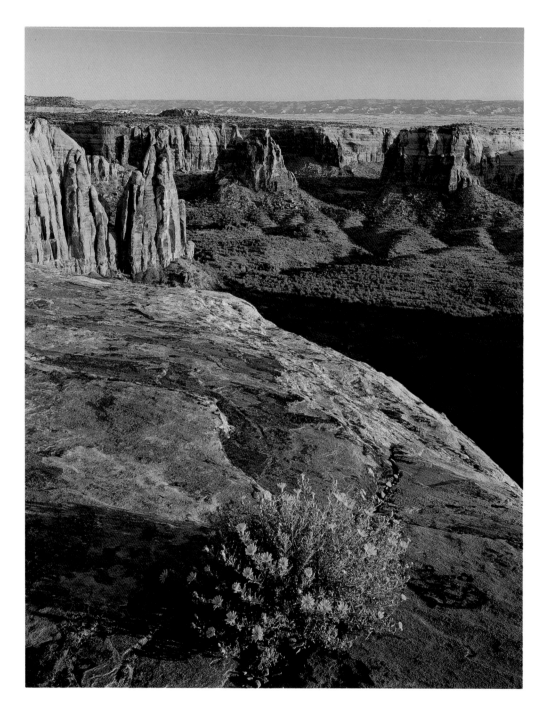

HAIRY GOLDENASTER
Heterotheca villosa

Monument Canyon
Monument Canyon Overlook
Colorado National Monument, Colorado
May 29, 1994

DOGTOOTH VIOLET
Erythronium grandiflorum
~ WITH FALSE HELLEBORE

Divide Road
Uncompahgre Plateau
Uncompahgre National
Forest, Colorado
May 29, 1994

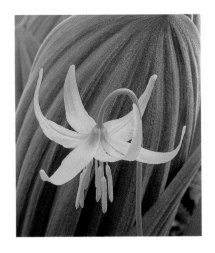

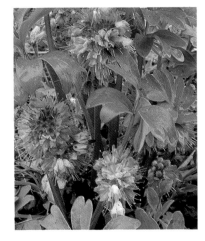

CAPITATE WATERLEAF
Hydrophyllum capitatum

Near Pulpit Rock Overlook
South Rim Road
Black Canyon of the
Gunnison National
Monument, Colorado
May 28, 1995

GOLDEN CORYDALIS
Corydalis aurea

Highway 53
El Malpais
National Monument
New Mexico
May 24, 1994

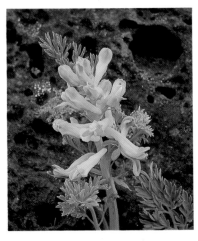

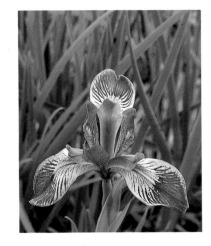

MISSOURI IRIS
Iris missouriensis

Highway 53
El Malpais National
Monument, New Mexico
May 24, 1994

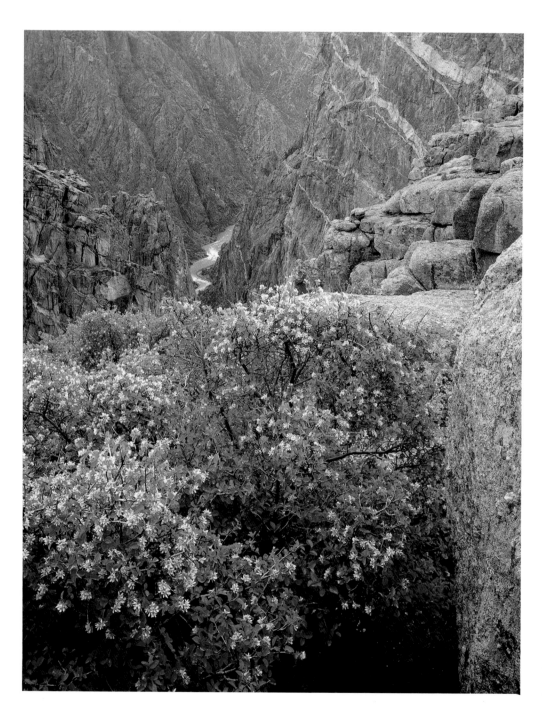

UTAH SERVICEBERRY
Amelanchier utahensis

Gunnison River
Painted Wall View, South Rim Drive
Black Canyon of the Gunnison
National Monument, Colorado
May 30, 1995

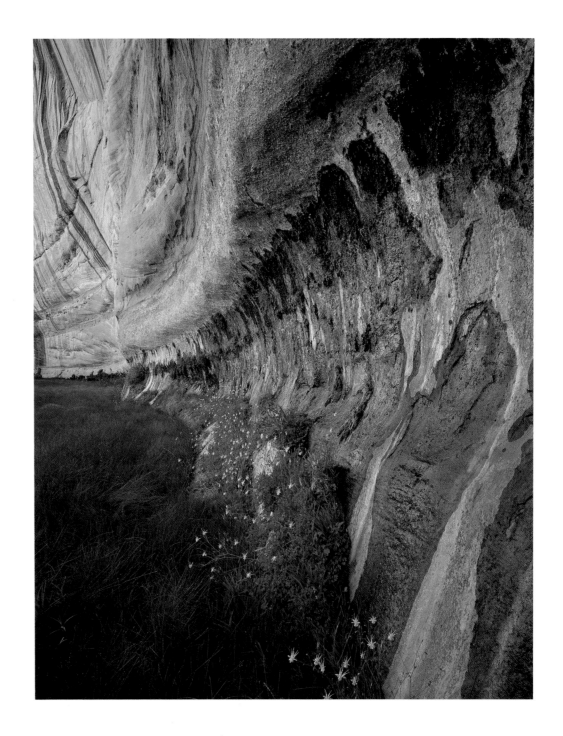

ALCOVE COLUMBINE
Aquilegia micrantha

Escalante River Canyon
Phipps–Death Hollow
Outstanding Natural Area
Bureau of Land Management
Escalante Resource Area, Utah
May 31, 1989

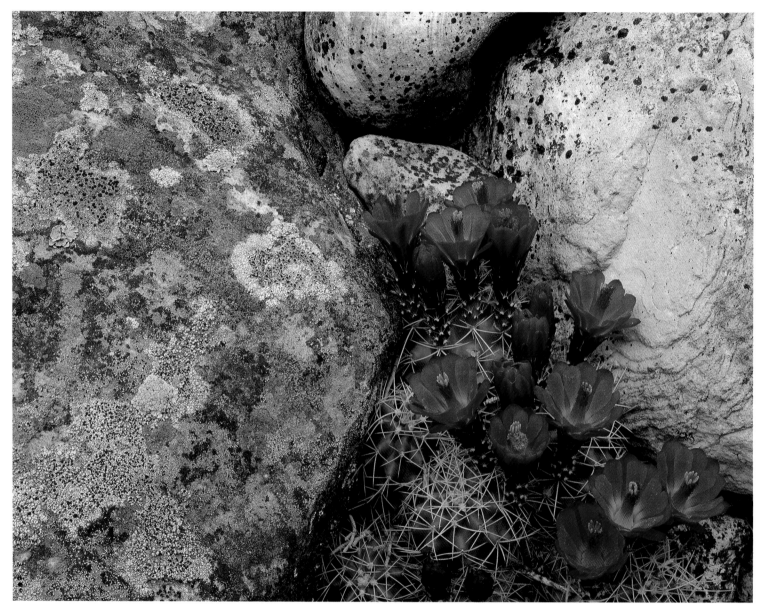

CLARETCUP CACTUS
Echinocereus triglochidiatus var. *melanacanthus*

Sand Canyon, Echo Park Road
Dinosaur National Monument, Colorado
May 31, 1994

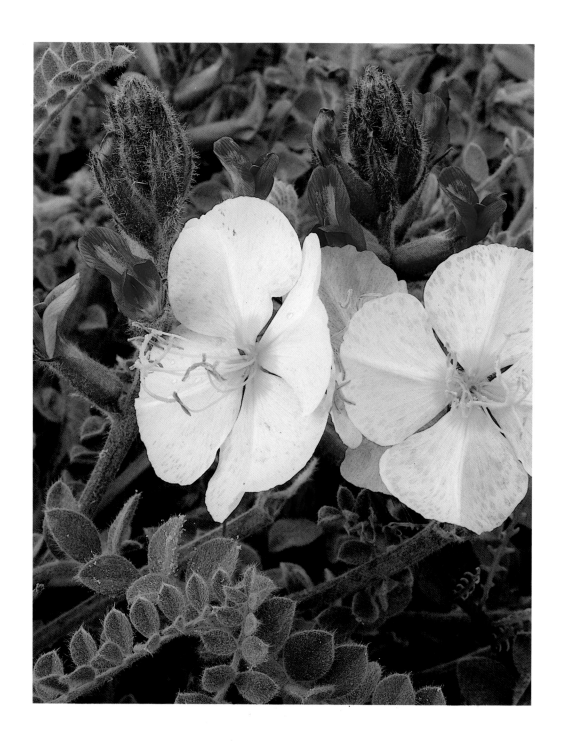

PALE EVENING–PRIMROSE
Oenothera pallida var. *trichocalyx*
WOOLLY LOCOWEED
Astragalus mollissimus var. *thompsonae*

Ute Canyon, Rim Rock Drive
Colorado National Monument
Colorado
May 24, 1995

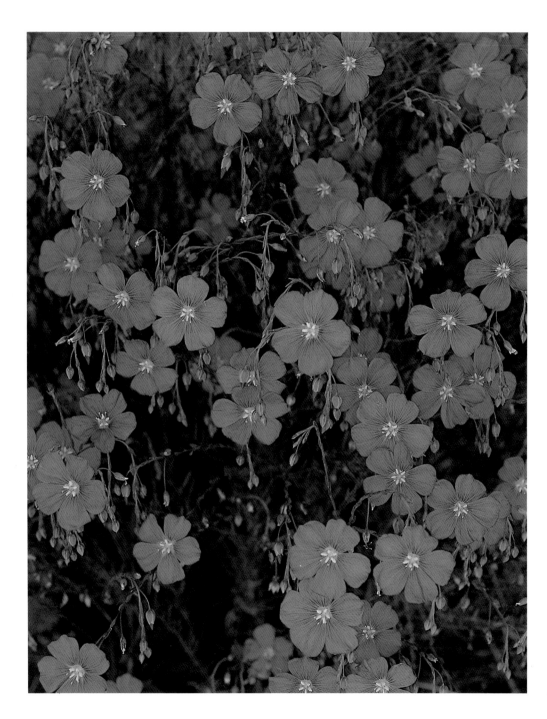

BLUE FLAX
Linum perenne

Chapin Mesa
Mesa Verde National Park
Colorado
June 3, 1995

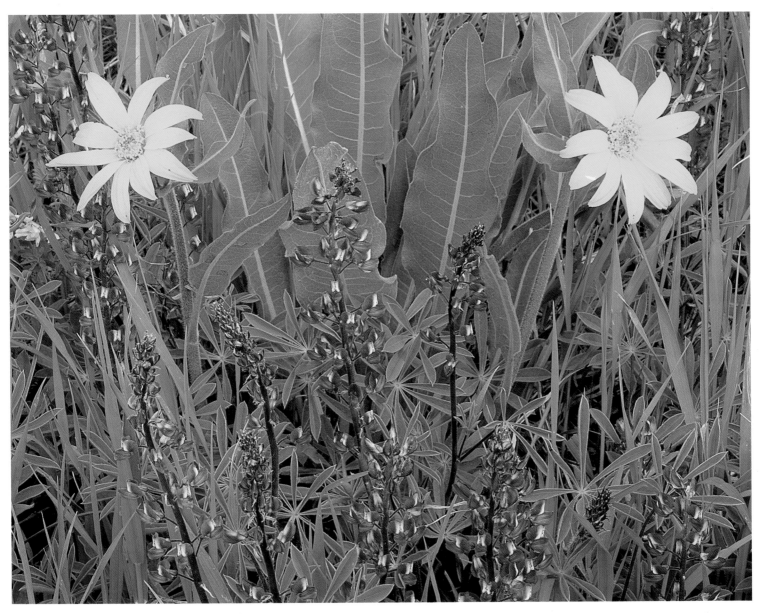

SAND LUPINE *Lupinus polyphyllus* var. *ammophilus*
ARIZONA MULESEARS *Wyethia arizonica*

North Rim, Wetherill Mesa Road
Mesa Verde National Park, Colorado
June 3, 1995

ARROWLEAF BALSAMROOT
Balsamorhiza sagittata

Whitman Bench near Fairview Point
Bryce Canyon National Park
Paunsaugunt Plateau, Utah
June 8, 1995

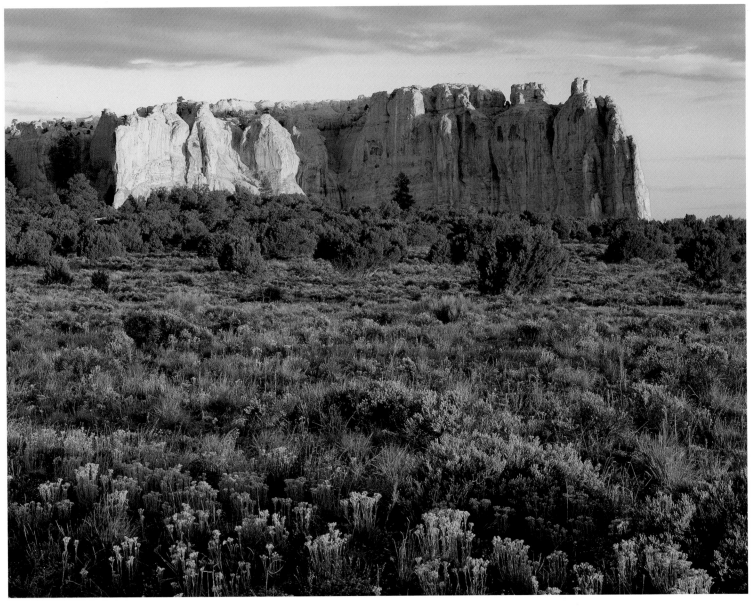

UINTA GROUNDSEL
Senecio multilobatus

El Morro National Monument, New Mexico
June 4, 1995

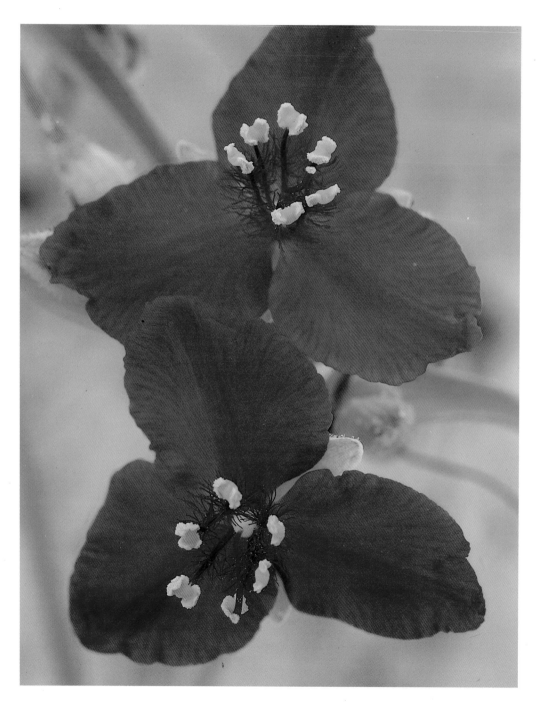

SPIDERWORT
Tradescantia occidentalis

Clear Creek Canyon
Zion–Mt. Carmel Highway
Zion National Park, Utah
June 7, 1995

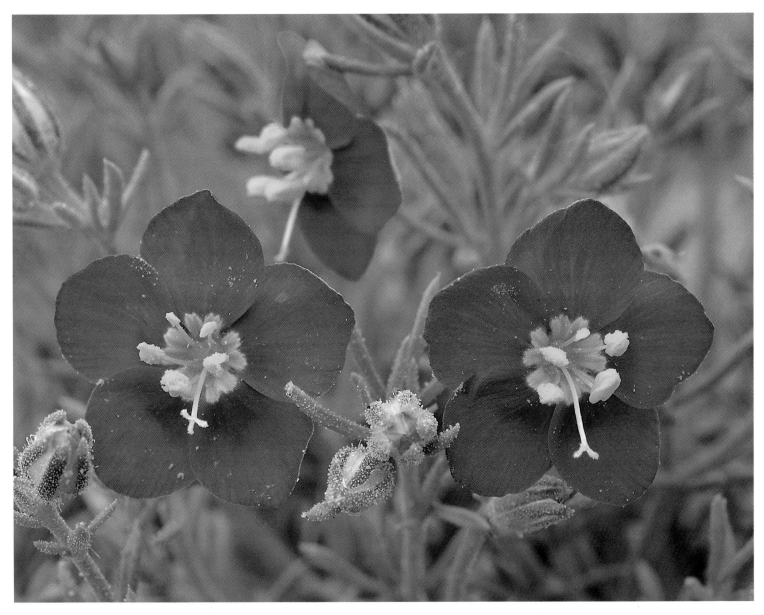

BLUE BOWLS
Gilia rigidula

Blue Mesa
Petrified Forest National Park, Arizona
May 14, 1995

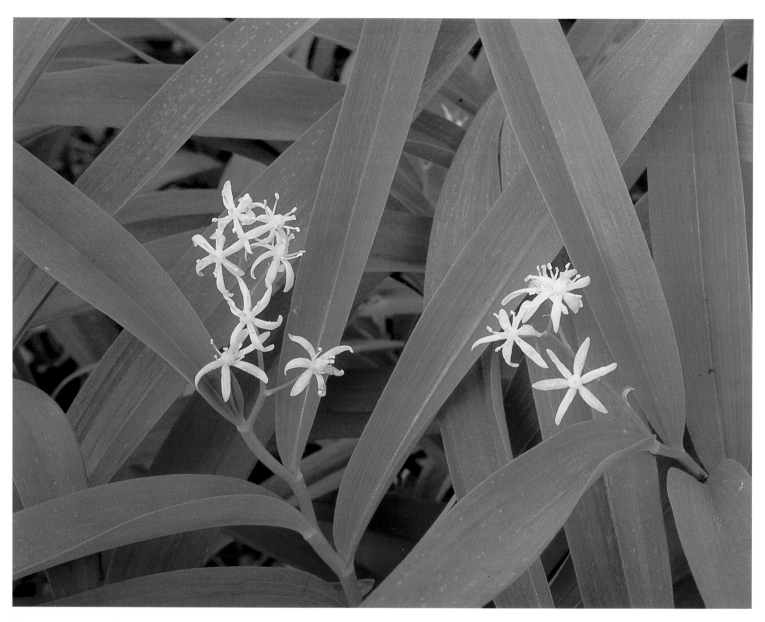

FALSE SOLOMON'S SEAL
Smilacina stellata

Prater Canyon
Mesa Verde National Park, Colorado
June 3, 1995

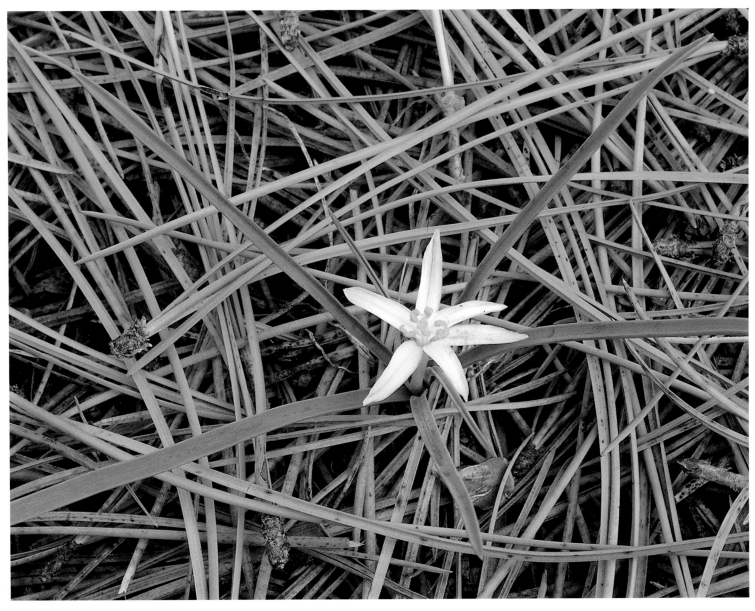

STAR-LILY *Leucocrinum montanum*

~ IN PONDEROSA PINE NEEDLES

Whitman Bench near East Creek
Bryce Canyon National Park
Paunsaugunt Plateau, Utah
June 7, 1995

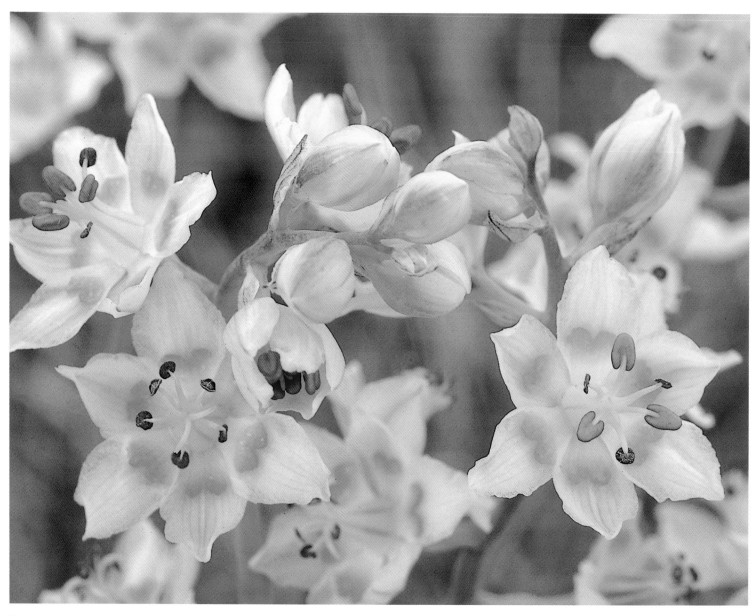

ELEGANT DEATH CAMAS Cedar Breaks National Monument
Zigadenus elegans Markagunt Plateau, Utah
 July 10, 1994

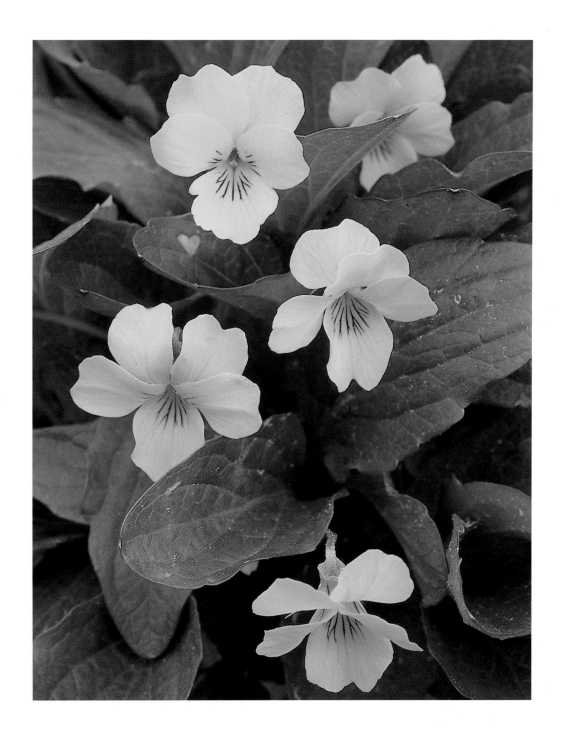

NUTTALL'S VIOLET
Viola nuttallii var. *major*

Lands End Road, Grand Mesa
Grand Mesa National Forest
Colorado
July 24, 1995

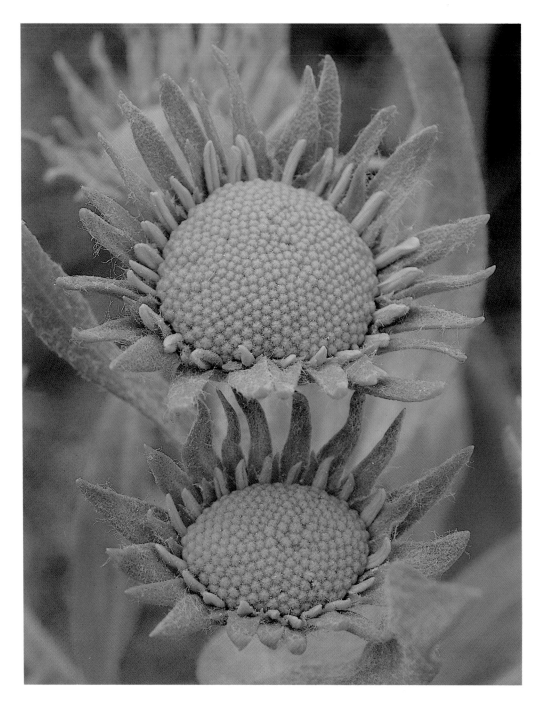

ORANGE SNEEZEWEED
Helenium hoopesii

Skyline Drive
Wasatch Plateau
Manti–La Sal National Forest, Utah
July 8, 1994

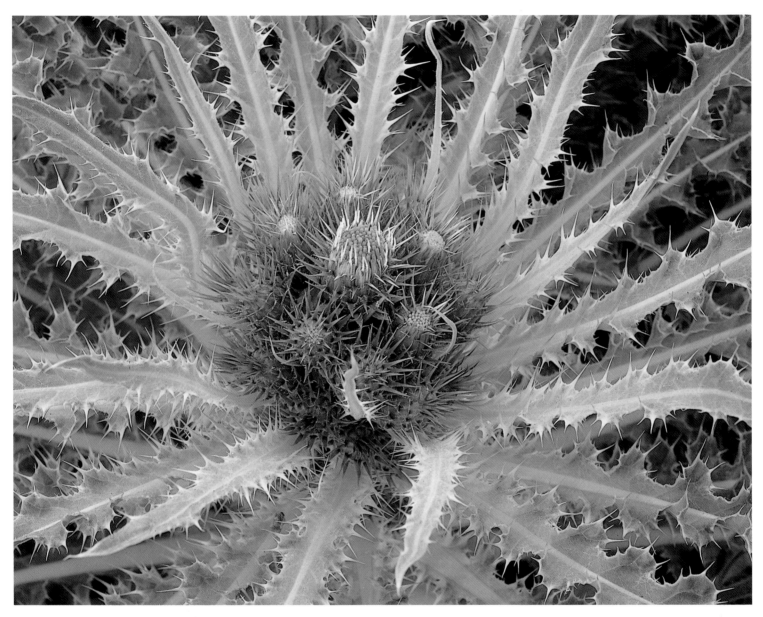

ELK THISTLE
Cirsium scariosum var. *scariosum*

Skyline Drive, Wasatch Plateau
Manti-La Sal National Forest, Utah
July 9, 1994

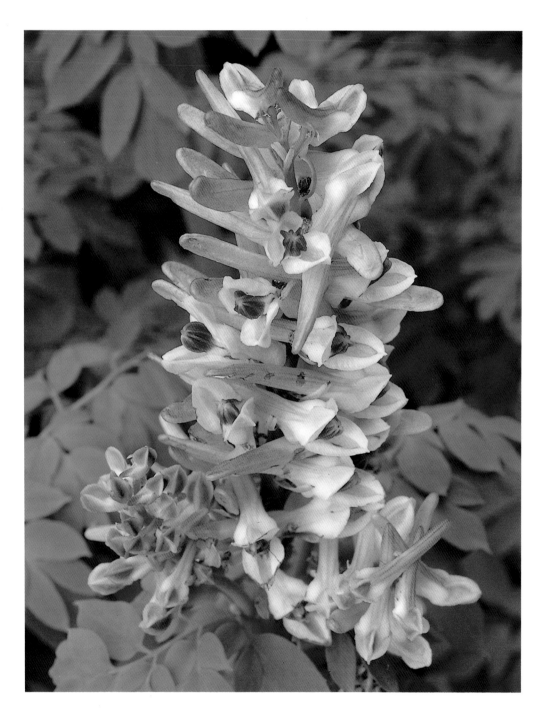

PINK CORYDALIS
Corydalis caseyana ssp. *brandegei*

Trickle Park Road, Grand Mesa
Grand Mesa National Forest
Colorado
July 12, 1994

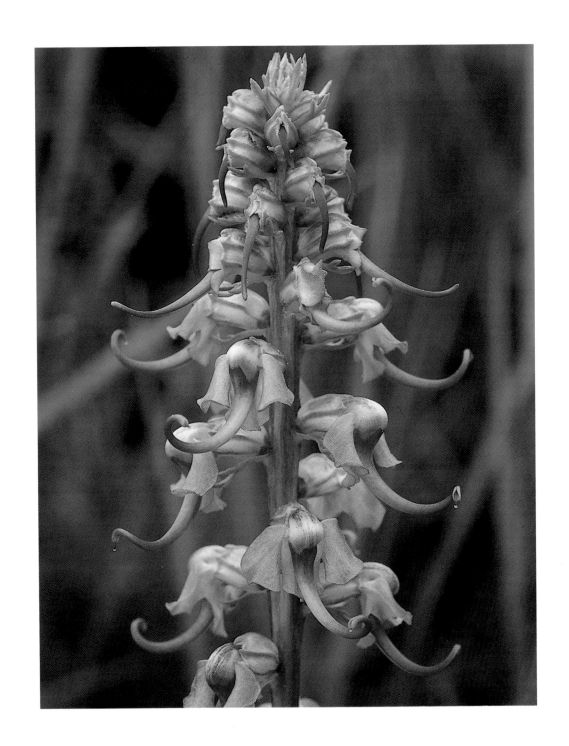

ELEPHANT-HEAD
Pedicularis groenlandica

Brian Head, Markagunt Plateau
Dixie National Forest, Utah
July 10, 1994

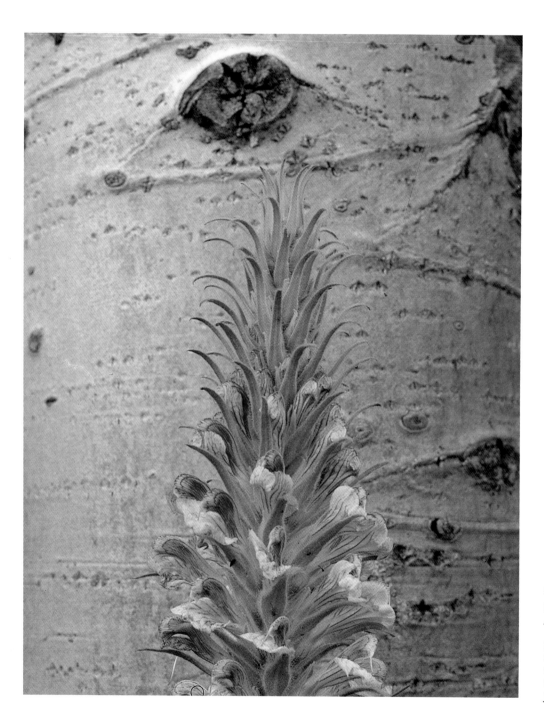

GRAY'S LOUSEWORT
Pedicularis procera
~ AGAINST ASPEN

Highway 65 near Mesa Lakes
Grand Mesa
Grand Mesa National Forest
Colorado
July 23, 1995

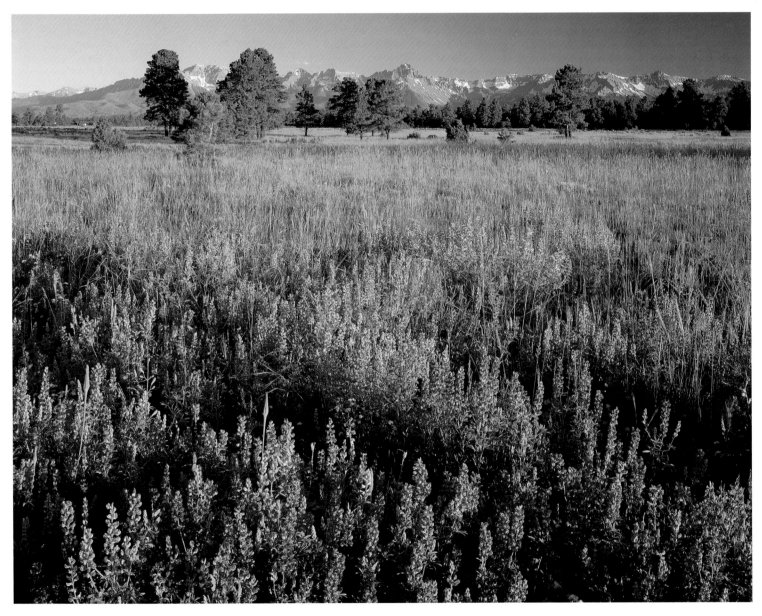

SILVERY LUPINE *Lupinus argenteus* var. *argenteus*
LINEARLEAF PAINTBRUSH *Castilleja linariifolia*
HEAD SANDWORT *Arenaria congesta* var. *congesta*

Sneffels Range in the San Juan Mountains, Log Hill Mesa
Uncompahgre Plateau, Colorado
July 25, 1995

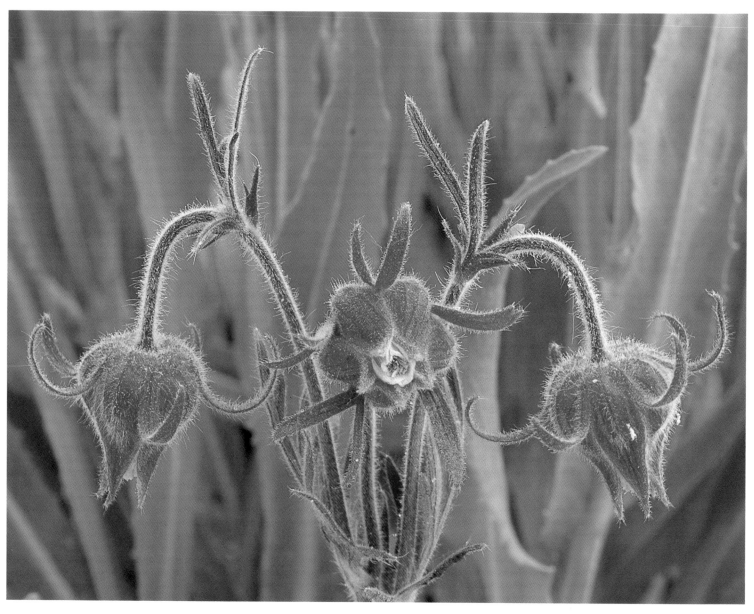

OLD-MAN'S-BEARD
Geum triflorum

Flowing Park Road, Grand Mesa
Grand Mesa National Forest, Colorado
July 12, 1994

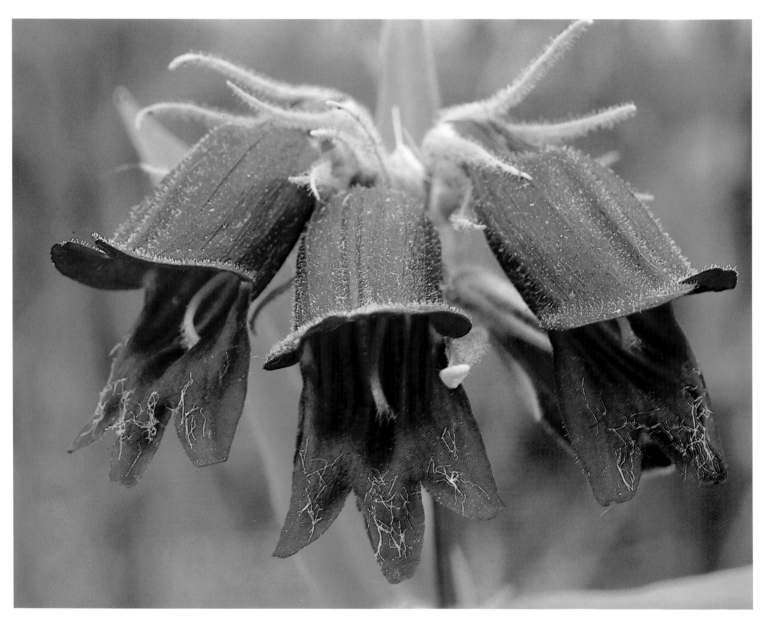

WHIPPLE'S PENSTEMON
Penstemon whippleanus

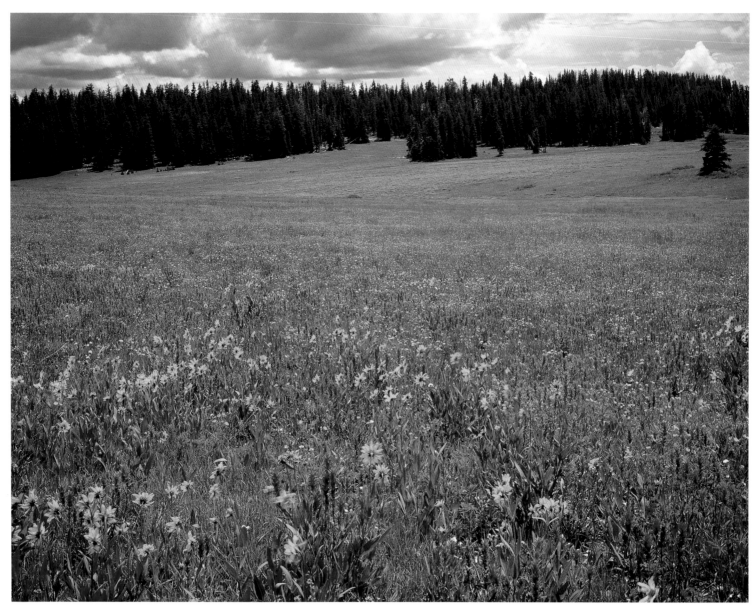

SCARLET PAINTBRUSH *Castilleja miniata*
ONEHEAD SUNFLOWER *Helianthella uniflora*

Cedar Breaks National Monument
Markagunt Plateau, Utah
July 24, 1984

WAVY-LEAF PAINTBRUSH
Castilleja applegatei
LANCELEAF PHACELIA
Phacelia hastata
STINKING HORSEMINT
Monardella odoratissima

Skyline Drive, Wasatch Plateau
Manti-La Sal National Forest, Utah
July 9, 1994

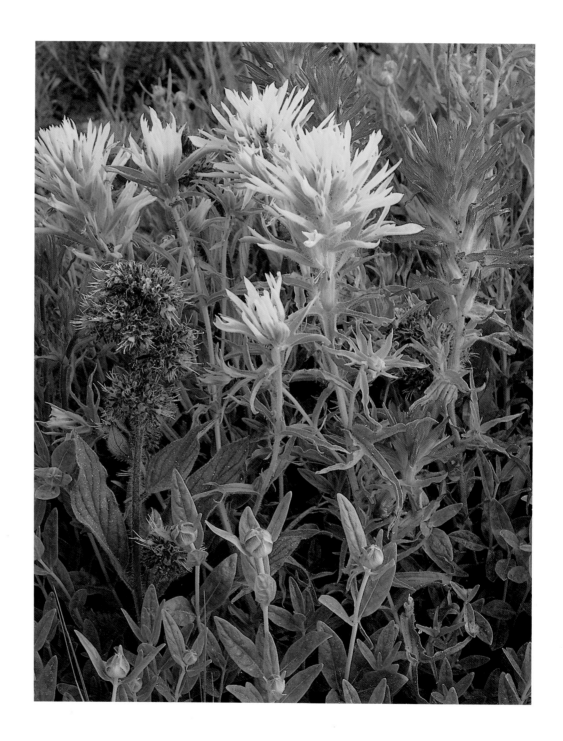

BLANKETFLOWER
Gaillardia aristata

Red Cloud Loop Road
Ashley National Forest
Uinta Basin, Utah
July 15, 1994

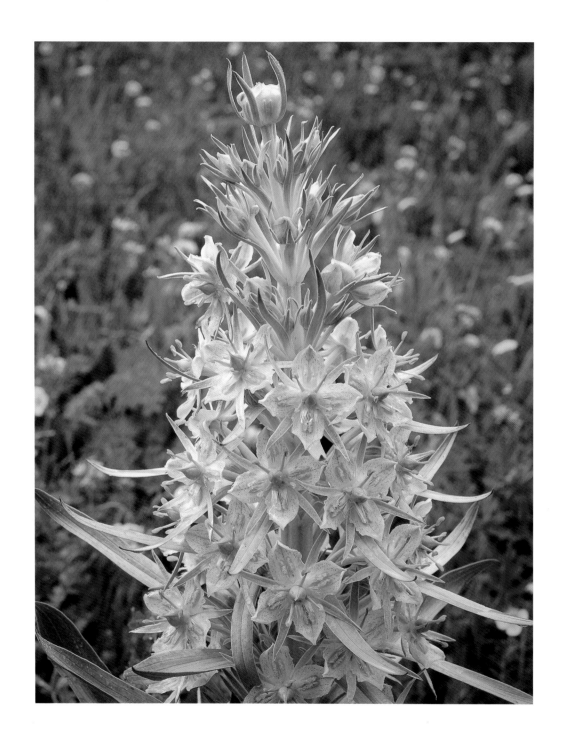

GREEN GENTIAN

Swertia radiata

Trickle Park Road, Grand Mesa
Grand Mesa National Forest
Colorado
July 28, 1988

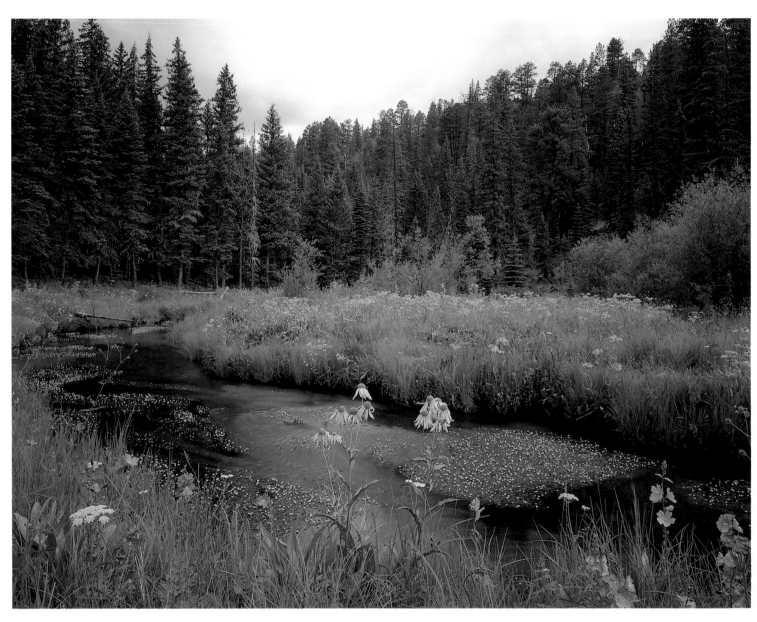

NEW MEXICO CHECKER *Sidalcea neomexicana*
SOUTHERN LIGUSTICUM *Ligusticum porteri*
ORANGE SNEEZEWEED *Helenium hoopesii*
WATER CROWFOOT *Ranunculus aquatilis*

West Fork Little Colorado River
White Mountains, Apache National Forest, Arizona
August 8, 1986

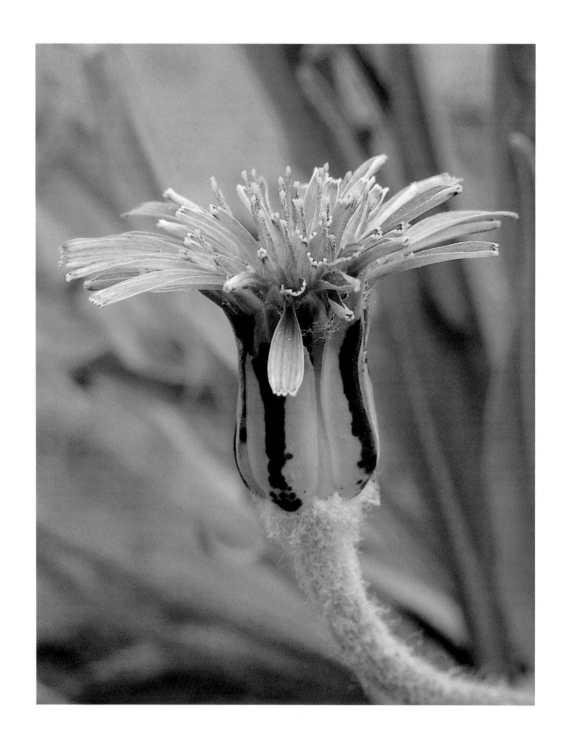

ORANGE AGOSERIS
Agoseris aurantiaca var. *aurantiaca*

Lands End Road, Grand Mesa
Grand Mesa National Forest, Colorado
July 12, 1994

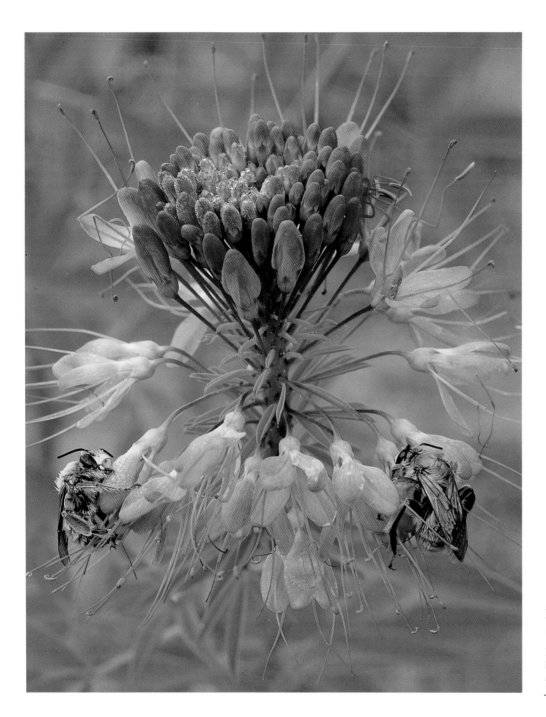

ROCKY MOUNTAIN BEEPLANT
Cleome serrulata

Keet Seel Canyon
Navajo National Monument
Arizona
July 24, 1986

WHEELER'S THISTLE
Cirsium wheeleri

West Fork Black River Valley
White Mountains, Apache National Forest, Arizona
August 12, 1986

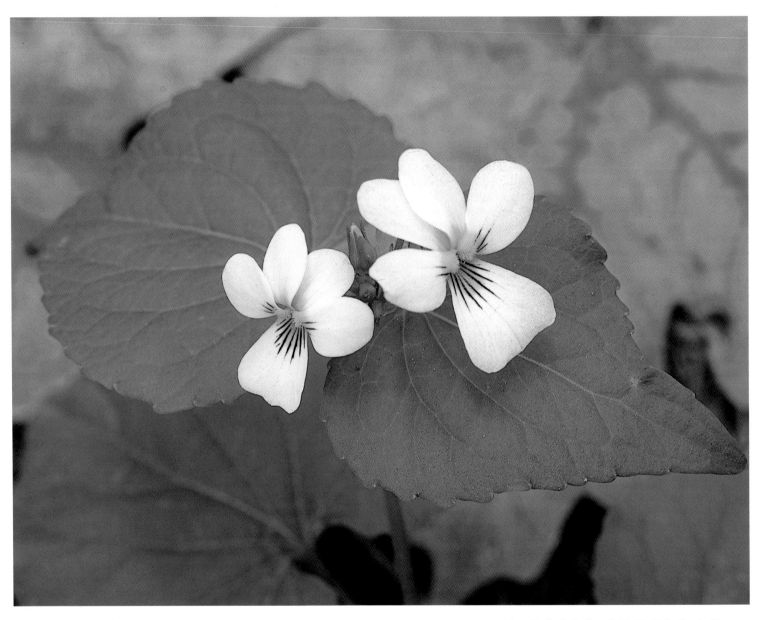

CANADA VIOLET

Viola canadensis

West Fork Oak Creek Trail, Oak Creek Canyon
Red Rock–Secret Mountain Wilderness
Coconino National Forest, Arizona
October 7, 1994

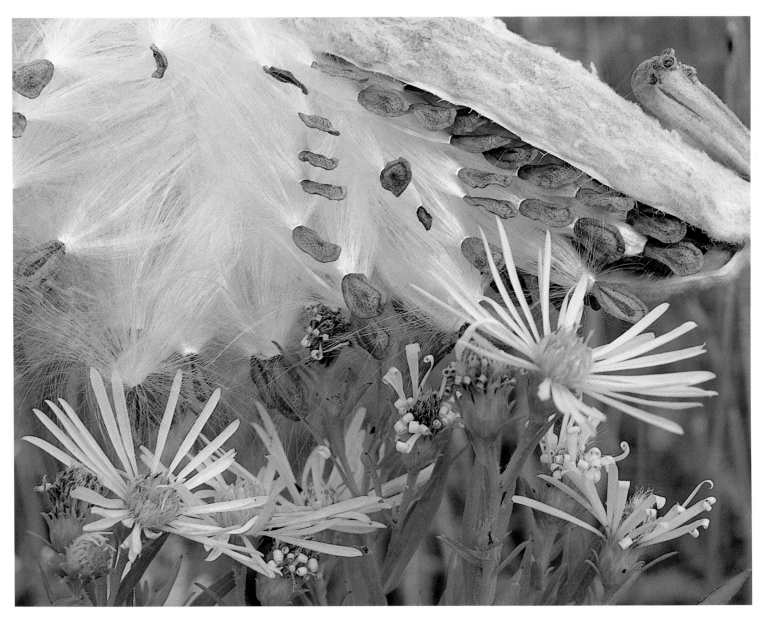

SISKIYOU ASTER *Aster hesperius*
~ WITH SHOWY MILKWEED SEEDPOD

Dolores River Canyon below McPhee Dam
Forest Road 504, San Juan National Forest, Colorado
September 28, 1994

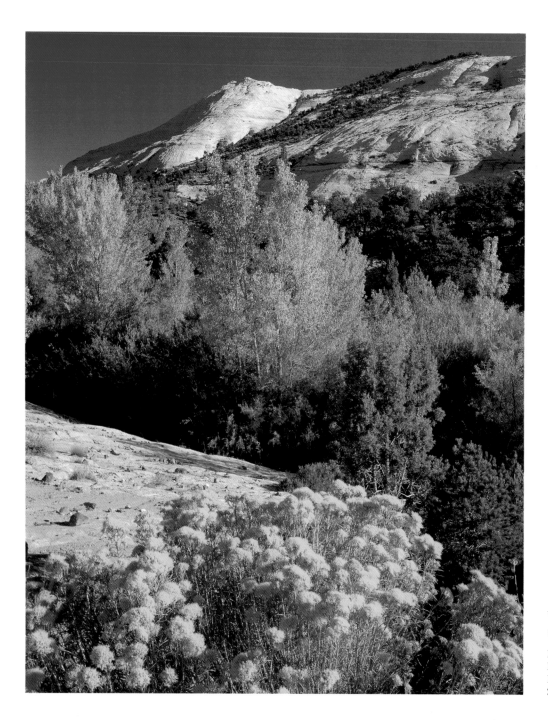

VISCID RABBITBRUSH
Chrysothamnus viscidiflorus var. *puberulus*

Deer Creek Drainage, Burr Trail
Bureau of Land Management
Escalante Resource Area, Utah
September 27, 1994

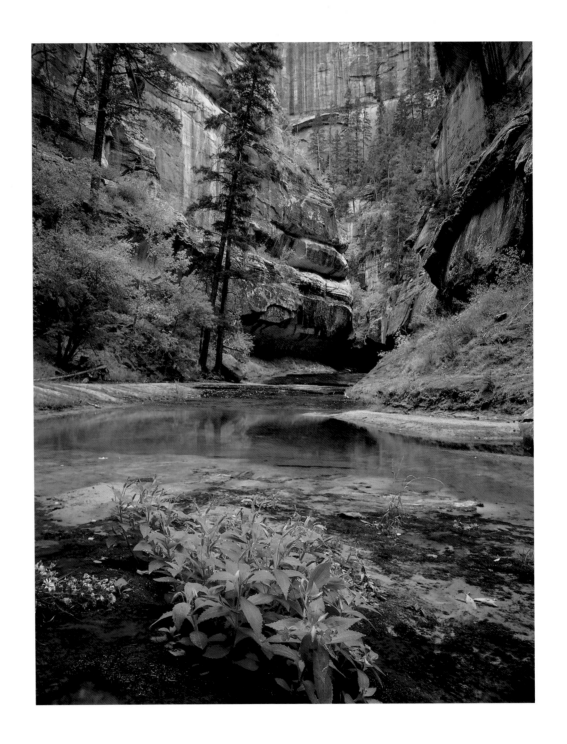

CARDINAL MONKEY–FLOWER
Mimulus cardinalis

The Subway, Left Fork North Creek
Zion National Park, Utah
October 14, 1987

HOARY ASTER
Machaeranthera canescens

El Morro National Monument
New Mexico
September 26, 1994

● *The wildflower species below bloom in these Plateau & Canyon Country Parklands:*

COMMON NAME	LATIN NAME	SHOWN ON PAGE(S):	Arches National Park	Black Canyon of the Gunnison National Park	Bryce Canyon National Park	Canyon de Chelly National Monument	Canyonlands National Park	Capitol Reef National Park	Cedar Breaks National Monument	Chaco Culture National Historical Park	Colorado National Monument	Dinosaur National Monument	El Malpais National Monument	El Morro National Monument	Glen Canyon National Recreation Area	Grand Canyon National Park	Hovenweep National Monument	Mesa Verde National Park	Natural Bridges National Monument	Navajo National Monument	Petrified Forest National Park	Sunset Crater National Monument	Walnut Canyon National Monument	Wupatki National Monument	Zion National Park
ALCOVE COLUMBINE	*Aquilegia micrantha*	11, 95	●		●	●	●		●	●				●						●	●				
ANNUAL WIRELETTUCE	*Stephanomeria exigua*	84	●		●	●	●		●	●	●		●	●	●					●	●				●
ARIZONA MULESEARS	*Wyethia arizonica*	99		●														●					●		●
ARMED PRICKLY-POPPY	*Argemone munita*	44													●	●									●
ARROWLEAF BALSAMROOT	*Balsamorhiza sagittata*	100		●	●				●	●						●									●
ARROWLEAF GROUNDSEL	*Senecio triangularis*	12 ‡																							‡
BANANA YUCCA	*Yucca baccata*	50, Back Cover			●	●				●			●	●	●	●	●	●	●	●	●		●		●
BEAUTY INDIGO-BUSH	*Psorothamnus arborescens*	44												●	●										
BLANKETFLOWER	*Gaillardia aristata*	118								●															
BLUE BOWLS	*Gilia rigidula*	103																		●					
BLUE FLAX	*Linum perenne*	98	●	●	●		●	●	●	●	●	●	●	●	●	●	●	●	●	●	●	●	●		●
BRITTLEBUSH	*Encelia farinosa*	Front Flap, 33														●									
BRONZE EVENING-PRIMROSE	*Oenothera howardii*	83			●			●																	●
BROOMRAPE	*Orobanche fasciculata*	60	●	●	●	●	●	●			●		●		●	●				●	●	●	●		
CANADA VIOLET	*Viola canadensis*	124			●			●	●							●									●
CAPITATE WATERLEAF	*Hydrophyllum capitatum*	93			●																				
CARDINAL MONKEY-FLOWER	*Mimulus cardinalis*	2, 26, 127														●									●
CARPET PHLOX	*Phlox hoodii*	78		●	●				●		●	●			●			●	●						●
CLARETCUP CACTUS	*Echinocereus triglochidiatus*	27, 64, 96	●	●	●	●	●	●	●	●	●	●	●	●		●		●	●	●			●		●
CLIFFROSE	*Purshia mexicana*	45	●		●	●	●	●			●				●			●	●	●					●
COLORADO COLUMBINE	*Aquilegia caerulea*	136			●			●	●							●									●
COMMON MONKEY-FLOWER	*Mimulus guttatus*	86	●		●		●				●				●	●				●			●	●	●

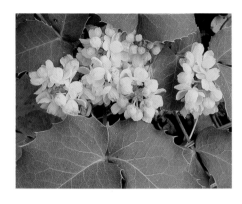

CREEPING MAHONIA
Mahonia repens

Divide Road
Uncompahgre Plateau
Uncompahgre National Forest
Colorado
May 29, 1994

● *The wildflower species below bloom in these Plateau & Canyon Country Parklands:*

COMMON NAME	LATIN NAME	SHOWN ON PAGE(S):	Arches National Park	Black Canyon of the Gunnison National Monument	Bryce Canyon National Park	Canyon de Chelly National Monument	Canyonlands National Park	Capitol Reef National Park	Cedar Breaks National Monument	Chaco Culture National Historical Park	Colorado National Monument	Dinosaur National Monument	El Malpais National Monument	El Morro National Monument	Glen Canyon National Recreation Area	Grand Canyon National Park	Hovenweep National Monument	Mesa Verde National Park	Natural Bridges National Monument	Navajo National Monument	Petrified Forest National Park	Sunset Crater National Monument	Walnut Canyon National Monument	Wupatki National Monument	Zion National Park	
COMMON PAINTBRUSH	*Castilleja chromosa*	1, 59	●	●	●	●	●	●			●	●				●	●	●	●	●		●			●	●
COMMON PRICKLYPEAR	*Opuntia erinacea*	31, 82	●		●	●	●				●	●				●	●	●	●	●						●
CREEPING MAHONIA	*Mahonia repens*	89, 129	●	●	●	●			●	●			●	●	●		●	●	●			●	●			●
CRENULATE PHACELIA	*Phacelia crenulata*	10, 52, 79	●			●	●	●			●	●				●	●	●	●	●				●	●	
CRESCENT MILKVETCH	*Astragalus amphioxys*	55, 77			●	●		●	●			●	●			●	●		●	●	●			●	●	●
DESERT LARKSPUR	*Delphinium parishii*	21													●				●							
DESERT MARIGOLD	*Baileya multiradiata*	29													●										●	
DESERT TRUMPET	*Eriogonum inflatum*	51	●			●	●				●	●			●	●	●							●	●	
DOGTOOTH VIOLET	*Erythronium grandiflorum*	93								●																
DWARF LUPINE	*Lupinus pusillus*	3, 52, 60	●			●	●		●		●				●	●										
DWARF MILKWEED	*Asclepias macrosperma*	131	●			●	●								●								●			
EASTWOOD'S CAMISSONIA	*Camissonia eastwoodiae*	51	●				●								●											
ELEGANT DEATH CAMAS	*Zigadenus elegans*	106	●		●		●	●	●									●					●		●	
ELEPHANT-HEAD	*Pedicularis groenlandica*	111							●																	
ELK THISTLE	*Cirsium scariosum*	109			●			●	●																●	
ENGELMANN HEDGEHOG-CACTUS	*Echinocereus engelmannii*	58					●								●	●										
FALSE SOLOMON'S SEAL	*Smilacina stellata*	104	●		●	●	●	●		●	●				●	●		●					●		●	
FENDLERBUSH	*Fendlera rupicola*	20	●	●		●	●				●				●	●		●								
FENDLER HEDGEHOG	*Echinocereus fendleri*	22			●							●			●					●	●		●			
FENDLER'S BLADDER-POD	*Lesquerella fendleri*	71								●				●	●					●						
FIVENERVE SUNFLOWER	*Helianthella quinquenervis*	136										●	●		●							●		●		
FRAGRANT SAND-VERBENA	*Abronia fragrans*	55	●		●	●	●	●			●	●	●		●	●	●		●	●				●	●	

129

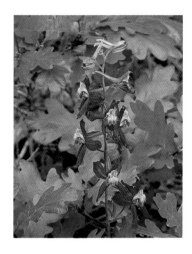

NELSON'S LARKSPUR
Delphinium nuttallianum
~with Gambel oak

South Rim, Grand Canyon
National Park, Arizona
June 5, 1995

● *The wildflower species below bloom in these Plateau & Canyon Country Parklands:*

COMMON NAME	LATIN NAME	SHOWN ON PAGE(S):	Arches National Park	Black Canyon of the Gunnison National Monument	Bryce Canyon National Park	Canyon de Chelly National Monument	Canyonlands National Park	Capitol Reef National Park	Cedar Breaks National Monument	Chaco Culture National Historical Park	Colorado National Monument	Dinosaur National Monument	El Malpais National Monument	El Morro National Monument	Glen Canyon National Recreation Area	Grand Canyon National Park	Hovenweep National Monument	Mesa Verde National Park	Natural Bridges National Monument	Navajo National Monument	Petrified Forest National Park	Sunset Crater National Monument	Walnut Canyon National Monument	Wupatki National Monument	Zion National Park
FREMONT'S MAHONIA	*Mahonia fremontii*	66, 73	●	●	●	●					●					●		●					●		●
GOLDEN COLUMBINE	*Aquilegia chrysantha*	36, 134														●									●
GOLDEN CORYDALIS	*Corydalis aurea*	93	●	●			●					●	●			●	●	●				●	●		●
GOLDEN MARIPOSA	*Calochortus aureus*	1, 67				●	●	●								●					●	●			●
GOLDEN PEA	*Thermopsis montana*	87					●					●						●	●			●			
GOOSE-BERRY-LEAF GLOBEMALLOW	*Sphaeralcea grossulariifolia*	3					●	●								●	●							●	●
GRAY'S LOUSEWORT	*Pedicularis procera*	112	‡																						‡
GREAT BLADDERY MILKVETCH	*Astragalus megacarpus*	57		●							●														
GREEN GENTIAN	*Swertia radiata*	119		●		●						●		●				●							
GREENLEAF MANZANITA	*Arctostaphylos patula*	18			●		●	●	●		●														
HAIRY GOLDENASTER	*Heterotheca villosa*	92	●		●		●	●	●		●				●	●		●		●				●	
HARRIMAN YUCCA	*Yucca harrimaniae*	91	●		●						●		●	●				●							
HEAD SANDWORT	*Arenaria congesta*	113		●			●					●						●	●						
HEARTLEAF BITTERCRESS	*Cardamine cordifolia*	12, 86						●	●																
HOARY ASTER	*Machaeranthera canescens*	21, 128		●			●	●			●	●				●		●			●	●			●
JIMSON WEED	*Datura wrightii*	37	●			●	●	●		●						●		●			●			●	●
KENNEDY'S MARIPOSA	*Calochortus kennedyi*	5, 49	‡																						‡
LAMBERT'S LOCOWEED	*Oxytropis lambertii*	76			●				●			●				●					●	●			
LANCELEAF PHACELIA	*Phacelia hastata*	117							●																
LAVENDERLEAF EVENING-PRIMROSE	*Calylophus lavandulifolius*	53, 74			●		●	●			●		●			●	●				●		●		
LINEARLEAF PAINTBRUSH	*Castilleja linariifolia*	113	●	●	●	●	●	●	●							●		●	●					●	●
LION'S-BEARD	*Clematis hirsutissima*	88		●												●		●							

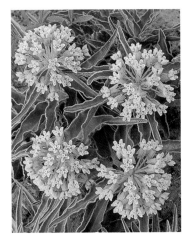

DWARF MILKWEED
Asclepias macrosperma

Dune Mesa
Arches National Park, Utah
May 23, 1995

● *The wildflower species below bloom in these Plateau & Canyon Country Parklands:*

COMMON NAME	LATIN NAME	SHOWN ON PAGE(S):	Arches National Park	Black Canyon of the Gunnison National Park	Bryce Canyon National Park	Canyon de Chelly National Monument	Canyonlands National Park	Capitol Reef National Park	Cedar Breaks National Monument	Chaco Culture National Historical Park	Colorado National Monument	Dinosaur National Monument	El Malpais National Monument	El Morro National Monument	Glen Canyon National Recreation Area	Grand Canyon National Park	Hovenweep National Monument	Mesa Verde National Park	Natural Bridges National Monument	Navajo National Monument	Petrified Forest National Park	Sunset Crater National Monument	Walnut Canyon National Monument	Wupatki National Monument	Zion National Park
LOW FLEABANE	*Erigeron pumilus*	68, 69	●		●	●	●			●	●			●		●	●	●							●
LOW SAND-VERBENA	*Abronia nana*	68			●			●							●	●									●
MISSOURI IRIS	*Iris missouriensis*	93			●			●				●				●		●			●				
MONKSHOOD	*Aconitum columbianum*	12				●	●									●									●
MOUNTAIN BLUEBELL	*Mertensia ciliata*	12, 13						●																	
MOUNTAIN PEPPERPLANT	*Lepidium montanum*	52	●		●		●	●			●	●			●	●	●	●	●						
NAKEDSTEM SUNRAY	*Enceliopsis nudicaulis*	7				●	●	●			●					●									
NARROWLEAF PENSTEMON	*Penstemon angustifolius*	63								●	●					●		●	●	●					
NARROW-LEAVED YUCCA	*Yucca angustissima*	90	●		●	●	●	●							●	●	●	●	●	●	●			●	
NELSON'S GLOBEMALLOW	*Sphaeralcea parvifolia*	46, 47	●		●	●	●	●		●	●				●	●	●	●	●		●		●	●	
NELSON'S LARKSPUR	*Delphinium nuttallianum*	130	●	●		●		●			●	●	●			●		●	●	●					
NEWBERRY'S TWINPOD	*Physaria newberryi*	41, 43	●		●	●	●								●	●	●					●		●	
NEW MEXICO CHECKER	*Sidalcea neomexicana*	120			●											●					●				
NUTTALL'S VIOLET	*Viola nuttallii*	107									●														
OCOTILLO	*Fouquieria splendens*	33														●									
OLD-MAN'S-BEARD	*Geum triflorum*	114						●																	
ONEHEAD SUNFLOWER	*Helianthella uniflora*	116			●			●			●														●
ORANGE AGOSERIS	*Agoseris aurantiaca*	121			●			●			●					●									●
ORANGE SNEEZEWEED	*Helenium hoopesii*	4, 25, 108, 120				●																			
PALE EVENING-PRIMROSE	*Oenothera pallida*	28, 97	●		●	●	●			●	●				●	●	●		●	●	●		●	●	●
PALLID MILKWEED	*Asclepias cryptoceras*	80	●					●		●	●					●									
PALMER'S PENSTEMON	*Penstemon palmeri*	54						●	●							●	●	●		●					●

131

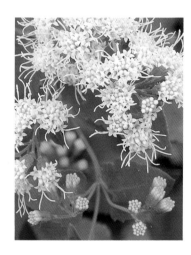

WHITE THOROUGHWORT
Eupatorium herbaceum

Long Canyon, Burr Trail
Bureau of Land Management
Escalante Resource Area, Utah
September 27, 1994

● *The wildflower species below bloom in these Plateau & Canyon Country Parklands:*

Common Name	Latin Name	Shown on Page(s):	‡	Arches National Park	Black Canyon of the Gunnison National Park	Bryce Canyon National Park	Canyon de Chelly National Monument	Canyonlands National Park	Capitol Reef National Park	Cedar Breaks National Monument	Chaco Culture National Historical Park	Colorado National Monument	Dinosaur National Monument	El Malpais National Monument	El Morro National Monument	Glen Canyon National Recreation Area	Grand Canyon National Park	Hovenweep National Monument	Mesa Verde National Park	Natural Bridges National Monument	Navajo National Monument	Petrified Forest National Park	Sunset Crater National Monument	Walnut Canyon National Monument	Wupatki National Monument	Zion National Park	‡
Peach Springs Breadroot	*Pediomelum retrorsum*	56	‡																								‡
Pink Corydalis	*Corydalis caseyana*	110	‡																								‡
Pinyon-juniper lousewort	*Pedicularis centranthera*	17, 89				●	●	●									●	●	●							●	
Plains pricklypear	*Opuntia polyacantha* var. *nicholii*	30		●		●	●	●			●	●	●			●	●	●	●							●	
Pretty buckwheat	*Eriogonum bicolor*	15		●		●	●	●								●										●	
Pretty phacelia	*Phacelia pulchella*	51														●	●										
Prince's plume	*Stanleya pinnata*	8, 40		●		●		●	●			●				●	●		●	●				●	●	●	
Prostrate verbena	*Verbena bracteata*	9		●		●	●	●			●	●	●	●		●				●		●					
Purple sage	*Poliomintha incana*	77		●		●	●									●	●							●	●		
Purplespot fritillary	*Fritillaria atropurpurea*	42			●			●	●	●		●					●										
Rocky Mountain beeplant	*Cleome serrulata*	122			●		●	●			●	●	●	●	●		●		●	●	●	●		●	●	●	
Rough mulesears	*Wyethia scabra*	75, 77		●		●	●					●				●	●			●							
Sand lupine	*Lupinus polyphyllus*	99		●			●									●											
Sand sunflower	*Helianthus anomalus*	6		●			●									●	●		●	●							
San Juan onion	*Allium macropetalum*	61		●			●	●		●						●			●	●	●						
Scapose greenthread	*Thelesperma subnudum*	3		●		●	●	●								●											
Scarlet-bugler penstemon	*Penstemon eatonii*	62		●	●	●		●								●	●	●	●							●	
Scarlet gilia	*Gilia aggregata*	72		●	●	●	●	●	●	●	●		●			●		●			●		●	●	●	●	
Scarlet paintbrush	*Castilleja miniata*	116				●		●		●		●				●										●	
Sego lily	*Calochortus nuttallii*	19		●		●		●	●			●				●	●		●		●					●	
Showy four-o'clock	*Mirabilis multiflora*	38, 50		●		●	●	●			●	●		●		●	●	●	●	●	●			●	●	●	
Showy lewisia	*Lewisia brachycalyx*	35																								●	

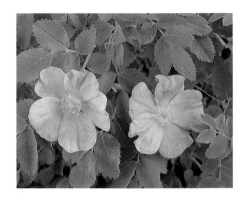

WOOD'S ROSE
Rosa woodsii

Sand Canyon, Echo Park Road
Dinosaur National Monument
Colorado
May 30, 1994

● *The wildflower species below bloom in these Plateau & Canyon Country Parklands:*

COMMON NAME	LATIN NAME	SHOWN ON PAGE(S):	Arches National Park	Black Canyon of the Gunnison National Park	Bryce Canyon National Park	Canyon de Chelly National Monument	Canyonlands National Park	Capitol Reef National Park	Cedar Breaks National Monument	Chaco Culture National Historical Park	Colorado National Monument	Dinosaur National Monument	El Malpais National Monument	El Morro National Monument	Glen Canyon National Recreation Area	Grand Canyon National Park	Hovenweep National Monument	Mesa Verde National Park	Natural Bridges National Monument	Navajo National Monument	Petrified Forest National Park	Sunset Crater National Monument	Walnut Canyon National Monument	Wupatki National Monument	Zion National Park
SILVERY LUPINE	*Lupinus argenteus*	25, 113	●		●	●	●	●		●	●	●							●	●			●		●
SIMPSON'S FOOTCACTUS	*Pediocactus simpsonii*	14		●			●				●	●												●	
SINUOUS MARIPOSA	*Calochortus flexuosus*	31			●						●	●				●									●
SISKIYOU ASTER	*Aster hesperius*	125	●																						
SLICKROCK PAINTBRUSH	*Castilleja scabrida*	15, 65	●			●	●				●				●				●						●
SOUTHERN LIGUSTICUM	*Ligusticum porteri*	120		●	●	●			●						●		●								
SPIDER MILKWEED	*Asclepias asperula*	23		●	●	●	●		●	●	●	●	●	●		●					●				
SPIDERWORT	*Tradescantia occidentalis*	102			●							●	●	●				●							
SPURRED LUPINE	*Lupinus caudatus*	Back Cover		●	●					●	●							●	●						
STAR-LILY	*Leucocrinum montanum*	105		●																					
STEMLESS WOOLLYBASE	*Hymenoxys acaulis*	59	●		●	●	●	●			●	●				●	●	●	●	●	●				
STINKING HORSEMINT	*Monardella odoratissima*	117		●	●			●	●						●										
STREAM ORCHID	*Epipactis gigantea*	81	●		●	●		●							●	●		●	●						●
SULPHUR PAINTBRUSH	*Castilleja rhexifolia*	25							●																
THOMPSON'S PENSTEMON	*Penstemon thompsoniae*	49	‡																						‡
TUFTED EVENING-PRIMROSE	*Oenothera caespitosa*	10, 79	●	●	●	●	●	●	●	●	●	●		●		●	●		●	●		●	●	●	●
TWINING SNAPDRAGON	*Maurandya antirrhiniflora*	16														●									
UINTA GROUNDSEL	*Senecio multilobatus*	101	●		●	●	●	●	●		●	●		●	●	●	●	●	●	●		●	●	●	●
UTAH CENTURY-PLANT	*Agave utahensis*	32													●	●									
UTAH DAISY	*Erigeron utahensis*	85	●			●	●								●	●	●	●	●						●
UTAH PENSTEMON	*Penstemon utahensis*	Front Cover	●		●		●	●							●	●		●							
UTAH SERVICEBERRY	*Amelanchier utahensis*	94	●	●		●	●	●	●		●	●			●	●	●	●	●			●			●

133

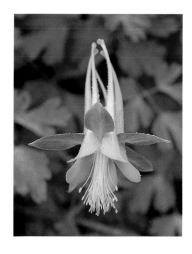

GOLDEN COLUMBINE
Aquilegia chrysantha var. *formosa*

Middle Emerald Pool
Emerald Pool Trail
Zion Canyon
Zion National Park, Utah
June 7, 1995

● *The wildflower species below bloom in these Plateau & Canyon Country Parklands:*

COMMON NAME	LATIN NAME	SHOWN ON PAGE(S):	Arches National Park	Black Canyon of the Gunnison National Monument	Bryce Canyon National Park	Canyon de Chelly National Monument	Canyonlands National Park	Capitol Reef National Park	Cedar Breaks National Monument	Chaco Culture National Historical Park	Colorado National Monument	Dinosaur National Monument	El Malpais National Monument	El Morro National Monument	Glen Canyon National Recreation Area	Grand Canyon National Park	Hovenweep National Monument	Mesa Verde National Park	Natural Bridges National Monument	Navajo National Monument	Petrified Forest National Park	Sunset Crater National Monument	Walnut Canyon National Monument	Wupatki National Monument	Zion National Park
UTAH YUCCA	*Yucca utahensis*	65													●										●
VIOLET BUTTERCUP	*Ranunculus andersonii*	34																							●
VISCID RABBITBRUSH	*Chrysothamnus viscidiflorus*	126	●		●	●	●	●			●	●	●	●	●	●		●	●			●		●	●
WATER CROWFOOT	*Ranunculus aquatilis*	120			●																				●
WAVY-LEAF PAINTBRUSH	*Castilleja applegatei*	117			●																				
WESTERN WALLFLOWER	*Erysimum asperum*	70	●	●	●		●	●	●	●	●	●	●	●	●	●		●	●		●	●			●
WHEELER'S THISTLE	*Cirsium wheeleri*	123			●					●			●		●	●						●			●
WHIPPLE'S FISHHOOK	*Sclerocactus whipplei*	48, 69	●		●	●	●	●			●			●			●	●	●						
WHIPPLE'S PENSTEMON	*Penstemon whippleanus*	115							●																
WHITE THOROUGHWORT	*Eupatorium herbaceum*	132			●									●								●			
WOOD'S ROSE	*Rosa woodsii*	133	●	●	●		●	●		●	●	●		●				●	●	●					●
WOOLLY LOCOWEED	*Astragalus mollissimus*	97	●			●	●		●	●	●	●	●	●	●		●	●	●						●
YELLOW BEEPLANT	*Cleome lutea*	46, 51	●		●		●		●		●			●	●	●									
YELLOW CRYPTANTH	*Cryptantha flava*	3, 76	●		●		●	●		●			●			●	●	●							
YELLOW-EYED CRYPTANTH	*Cryptantha flavoculata*	53	●			●	●			●			●			●			●						●
YELLOW RAGWEED	*Bahia dissecta*	9			●								●	●		●		●		●			●	●	
ZION [PRETTY] SHOOTING-STAR	*Dodecatheon pulchellum*	39			●			●			●			●											●

‡ *Some species appear on public or private lands outside national parkland boundaries.*

Acknowledgements

Identifying scientific names of species was important for this project. Keying out to Latin names—and finding a consensus on common names—became almost as great a challenge as the photography. I used many references to achieve this goal, but my primary tool was *A Utah Flora* by Stanley L. Welsh, et al. Many fine folks gave welcome advice and reassurance on species names and distribution. Thanks go out to the botanists and interpretive specialists in the National Park Service including Marilyn Colyer at Mesa Verde, Hardy Delafield, Jr. at Dinosaur, Jeri DeYoung at Wupatki, Dan A. Foster at Bryce Canyon, David Humphries at Petrified Forest, Margaret Malm at Zion, Karen Mason at Capitol Reef, Bruce Mellberg at Navajo, Patrick Perroti at Colorado, Herschel Schulz at Chaco Culture, Tara Travis at Canyon de Chelly, and Tara Williams at Canyonlands. I would also like to thank David Bleakly of Bleakly Botanical & Biological and Wendy Hodgson at the Desert Botanical Garden. Special thanks go to Nancy Brian at Grand Canyon, John Spence at Glen Canyon, and to Stanley Welsh at Brigham Young University. —Larry Ulrich

Selected images from *Wildflowers of the Plateau & Canyon Country* are available as limited edition EverColor DyePrints from Moments in Time, Ltd. of California. Each ready-to-frame hand-pulled print is museum-quality matted, border embossed, stamped with a registry number, and accompanied by a certificate of authenticity signed by the photographer. For selection and ordering information, call (800) 533-5050.

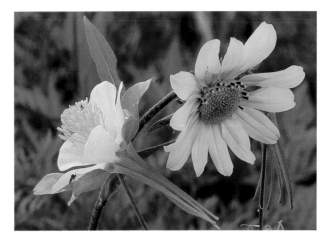

FIVENERVE SUNFLOWER
Helianthella quinqenervis
COLORADO COLUMBINE
Aquilegia caerulea

Trickle Park Road, Grand Mesa
Grand Mesa National Forest, Colorado
July 12, 1994

PHOTOGRAPHER'S NOTES

I used an assortment of photographic equiment in making these images. My primary tools since 1975 have been several generations of Arca–Swiss view cameras which I shoot in both 4x5 and $2\frac{1}{4}$ and $2\frac{3}{4}$ formats. The 4x5 works best for the grand landscapes, the $2\frac{1}{4}$ x $2\frac{3}{4}$ for close-ups. Most 35mm work was done with a Nikkor 60mm f 2.8 micro lens on a Nikon 8008. I often used a polarizing screen for the view camera shots to reduce glare and contrast. For much of the close-up work I employed the use of flexible loops stretched with fabric, called Flex Fills, both to shield my subject from the wind and create soft light by shading. I also modified a Bogen tripod to lay flat on the ground. The older images were shot using Kodak Ektachrome 64 daylight film; after 1990 I used Fuji Velvia film.